EAST DULWICH
THROUGH TIME
John D. Beasley

AMBERLEY PUBLISHING

Acknowledgements

Among the many people to whom I am grateful are the helpful and knowledgeable staff of Southwark Local History Library (Stephen Humphrey, Steve Potter, Bob Askew, Lucy Tann and Lisa Soverall); Gill Frost (who read the typescript and made many useful suggestions); W. H. Blanch who wrote *Ye Parish of Camerwell* and other people who recorded local history by writing, taking photographs and painting local scenes; the people who gave me photographs of cricket being played on King's College Sports Ground before it was destroyed by Sainsbury's; Brian Green for writing books on Dulwich that include East Dulwich; all the people who have worked for the East Dulwich Society since it was founded in 1974; people who have provided me with photographs including Mr D. J. Beer (Macclesfield), Mandy Burnett, Judith Coxon, Brian Leonard and Phil Poleglaze; Sarah Flight of Amberley Publishing for her friendly and helpful co-operation; other people who have assisted in various ways.

First published 2009

Amberley Publishing Plc
Cirencester Road, Chalford,
Stroud, Gloucestershire, GL6 8PE

www.amberley-books.com

Copyright © John D. Beasley, 2009

The right of John D. Beasley to be identified as the Author of this work has been asserted in accordance with the Copyrights, Designs and Patents Act 1988.

ISBN 978 1 84868 550 5

British Library Cataloguing in Publication Data. A catalogue record for this book is available from the British Library.

Typeset in 9.5pt on 12pt Celeste.
Typesetting by Amberley Publishing.
Printed in the UK.

Introduction

A research project on Lordship Lane was undertaken by Dr Eeva Berglund in 2007. This showed how the main shopping street in East Dulwich has changed significantly in recent years. Most of the new shops indicate how SE22 has gone upmarket in the last few years. New housing has been built and many of the new residents use East Dulwich Station. That's not surprising because trains take only fourteen minutes to reach London Bridge Station.

Despite the gentrification, East Dulwich is a well-preserved Victorian suburb. It has a high percentage of nineteenth-century houses. Many Victorian shops and other buildings still exist. Today's residents benefit from the vision and work of people in the nineteenth century who created Peckham Rye Park, which is the most beautiful park in the London Borough of Southwark. Another important open green space is Goose Green, the former village green.

Charles Booth's survey *Life and Labour of the People in London* sheds much light on what East Dulwich was like for the people who lived there at the end of the nineteenth century.

Blue plaques remind us of former residents who achieved fame or deserved to do so, including writer Enid Blyton, novelist C. S. Forester, film star Boris Karloff and the founder of the blood donor service Percy Lane Oliver.

Other well-known people with East Dulwich links include novelist and art historian Anita Brookner, who attended James Allen's Girls' School; Lord Byron, who was a pupil at Dr Glennie's Academy; actor Lorraine Chase, who lived in Riseholme House on the East Dulwich Estate and went to Dog Kennel Hill School; actor Ken Farrington,

who was born in Dulwich Hospital; fashion designer John Galliano, who attended St Anthony's Roman Catholic School; composer Gustav Holst, who taught at James Allen's Girls' School; Dulwich Hamlet footballer Edgar Kail, who was a pupil at Goodrich School; writer John Middleton Murray, who lived in Worlingham Road; Bishop Lesslie Newbiggin, who was a member of Dulwich Grove United Reformed Church; composer Ralph Vaughan Williams, who taught singing at James Allen's Girls' School; music professor Sir Jack Westrup, who was a pupil at Alleyn's School.

More information about these people is included in *East Dulwich: An Illustrated Alphabetical Guide,* which was the first book to be written exclusively about SE22. It is commendable that Chener Books of Lordship Lane celebrated their 30th anniversary in 2008 by publishing a second edition. The book's addendum highlights major changes that happened in the ten years following its original publication in 1998.

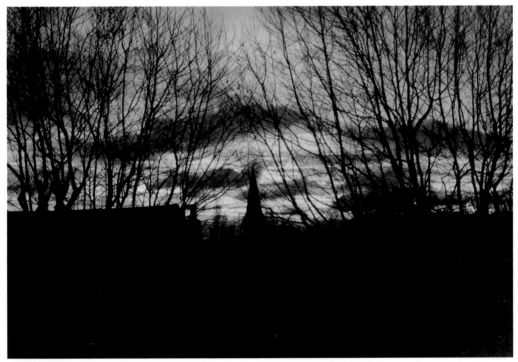

A beautiful sunrise was seen on 26 February 2007. The photograph was taken from the loft bedroom at 6 Everthorpe Road, Peckham. The spire of St John the Evangelist church at Goose Green is in the centre.

The Goose Green roundabout, with its palm tree from Chile, is an attractive feature at the approach to the Lordship Lane shopping centre. Local people ran two successful campaigns to retain the roundabout that was created after tram lines were removed in the early 1950s.

The East Dulwich Society has been campaigning energetically since 1974. There is a need for additional local people to become active in the Society. If more of the new residents were to become involved in the amenity society for SE22 it would be able to do even more to preserve its heritage and improve the quality of life for people in East Dulwich.

Though I have lived in Peckham for thirty-seven years, I refer to Grove Vale as my village street because it is only a few minutes' walk from my home. I enjoy the friendliness, fun and good service I receive in all the shops I use in Grove Vale.

More people in East Dulwich could benefit from adopting the village concept. In their minds they should draw an imaginary circle with a diameter of a quarter of a mile around their home. Inside the circle is their 'village'. That area is small enough for them to get to know a lot of people as they walk around local streets and is an effective way to improve the quality of life in an inner London suburb.

East Dulwich would certainly be better if more residents had a greater sense of community. This includes cyclists following *The Highway Code* and not cycling on pavements and the wrong way along one-way streets. East Dulwich has a rich heritage and the present residents have opportunities to leave a positive legacy for future generations to enjoy just as they benefit from the vision and activities of former residents.

John D. Beasley

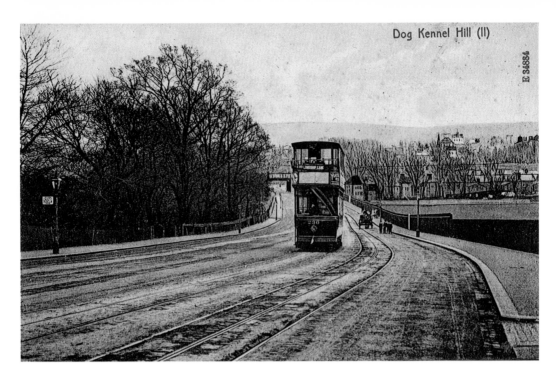

Dog Kennel Hill
A tram climbs up Dog Kennel Hill. Tram tracks were laid in 1906 and the number of tracks on Dog Kennel Hill was later increased to four, for safety reasons, so no trams could follow each other on the same line.

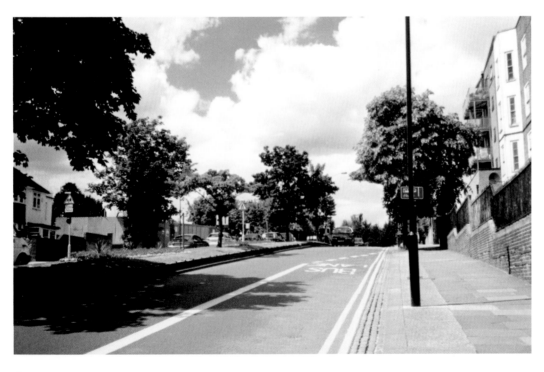

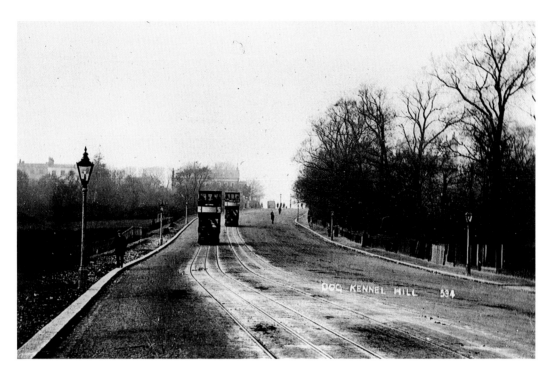

Tram Model

In sharp contrast to Dog Kennel Hill in the twenty-first century, no cars can be seen. Trams ceased running on Dog Kennel Hill in 1951. After the tramlines were removed, the granite blocks which had held them in place were used to build the central reservation. An illustrated article on a model made by John Howe of trams on Dog Kennel Hill was published in *Railway Modeller* in September 2008.

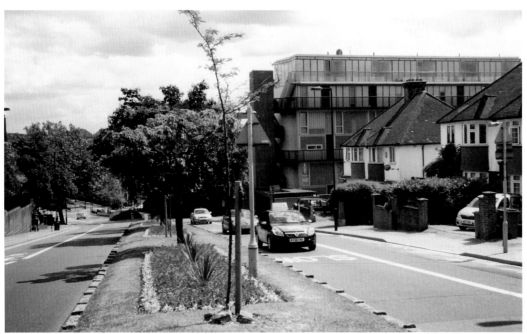

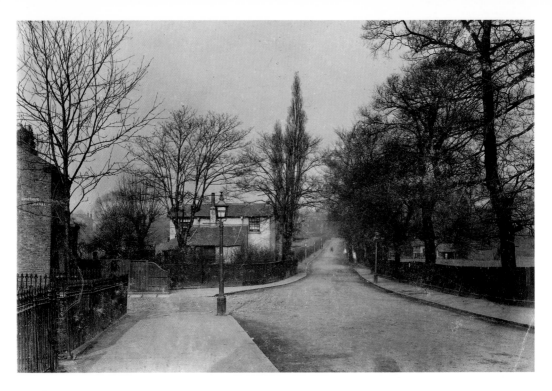

Rural Lane

In 1890, Dog Kennel Hill was a rural lane. Constance Road, which became St Francis Road, is on the left. The house in the centre of the picture was demolished in 1906 to make room for tramlines. There were fields on the east side of the hill where the London County Council built the East Dulwich Estate in the 1930s.

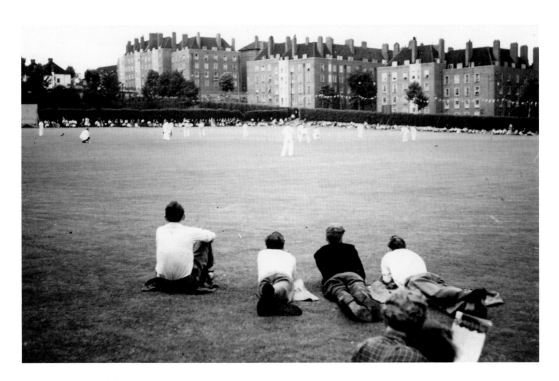

East Dulwich Estate

A clear view of the East Dulwich Estate on the east side of Dog Kennel Hill was seen by spectators enjoying a cricket match on King's College sports ground. The London County Council built the estate in the 1930s. In contrast, there was a snowy scene in February 2009, as seen from East Dulwich Station when eight inches of snow prevented trains from running.

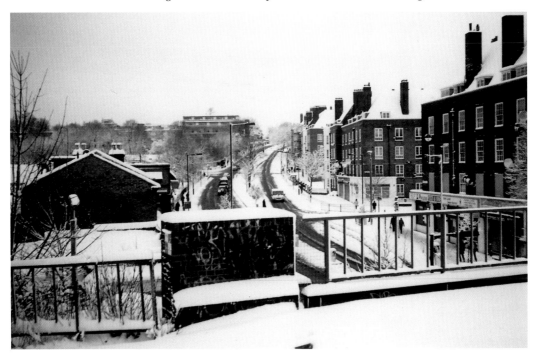

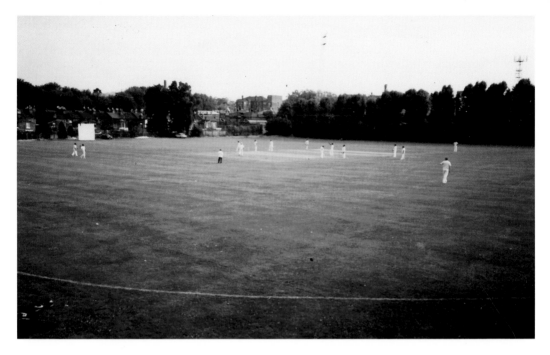

Cricket being Played

Cricket was one of the games played on King's College sports ground at Dog Kennel Hill. Sainsbury's destroyed over eight acres of open green space in a semi-rural part of East Dulwich. The car park and road to the store were built on much of the sports ground and the store was built on Dulwich Hamlet Football Club's practice pitch. Despite Tree Preservation Orders, many trees were cut down when the building work took place. The story of the vigorous campaign against the Sainsbury's store and the damaging effects it had on local shops is told in *Save Green Spaces from Destruction by Food Giants*.

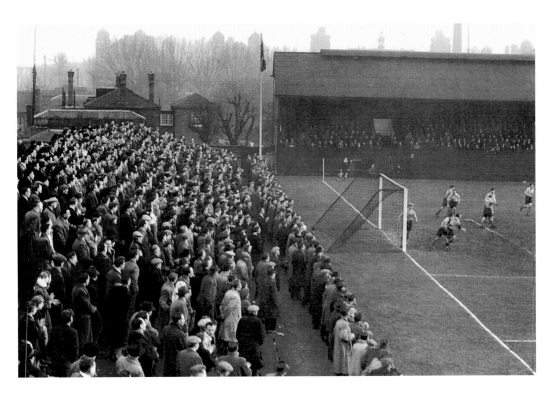

Dulwich Hamlet Football Club

Large crowds were attracted to Dulwich Hamlet Football Club's old ground, which opened in 1931. It was totally rebuilt in 1992. The first known reference to the club can be found in the *South London Press* of 18 February 1893. The newspaper included a report that 'A meeting of the "old boys" of the Hamlet Board School was held to discuss the formation of a "Dulwich Hamlet Old Boys' Club".' The report stated: 'The formation of various clubs was discussed, and immediate steps were taken respecting cricket and swimming, to be followed in due course by field, football and kindred clubs.'

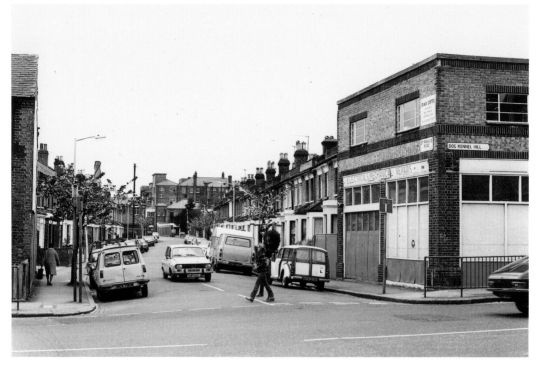

St Francis Road

St Francis Road, seen above in 1981, was originally called Constance Road. It was renamed St Francis Road in 1969 as it led to St Francis Hospital, which was originally the Constance Road Workhouse. The road was the only way for people and vehicles to gain access to the workhouse and later the hospital.

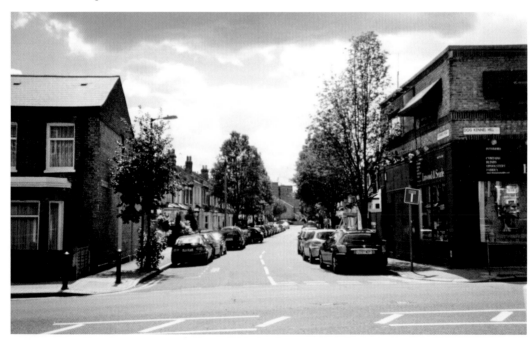

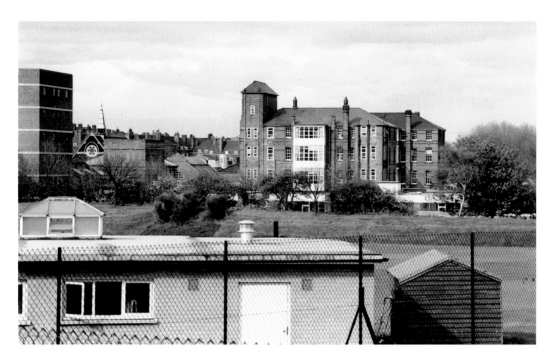

St Francis Hospital

The site of St Francis Hospital is now occupied by St Francis Place. St Francis Road led to the hospital entrance. Originally the building was Constance Road Workhouse, which had been built for the Camberwell Guardians of the Poor. It opened in 1895 and had accommodation for 898 inmates. Later it became the Constance Road Infirmary and specialised in looking after the 'deserving poor' as well as those who were mentally ill, physically handicapped or elderly. It also cared for unmarried mothers. St Francis Hospital closed in 1991.

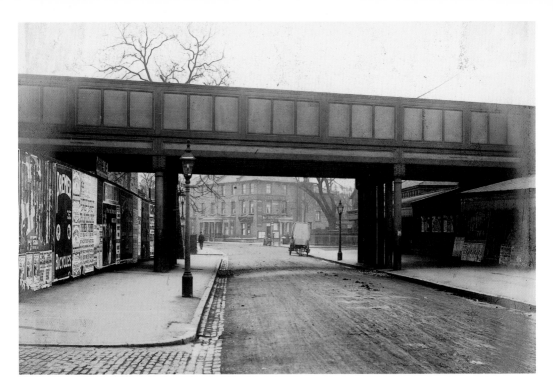

Grove Vale

Grove Vale in 1906 was not the busy road it is today. However, a century later it is occasionally possible to see not a single vehicle on the road, as this photograph shows. It was taken on 1 March 2008 at about 7.05 a.m.

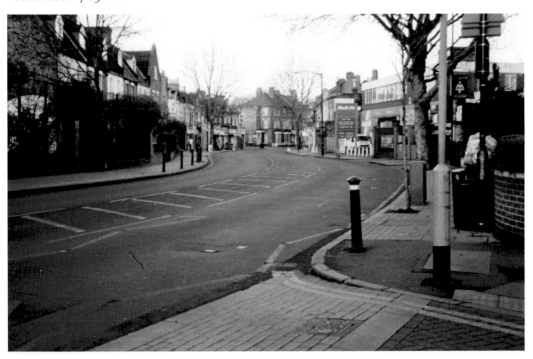

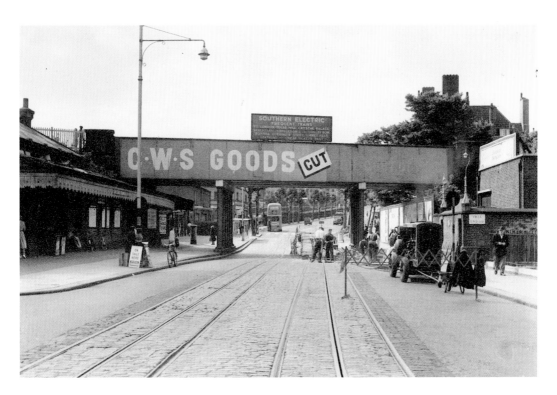

East Dulwich Station

Tramlines were being removed in Grove Vale when the photograph above was taken in 1952. The canopy over the entrance to East Dulwich Station and the men's urinal next to Vale End no longer exist. The CWS advert on the railway bridge was for the Co-operative Wholesale Society.

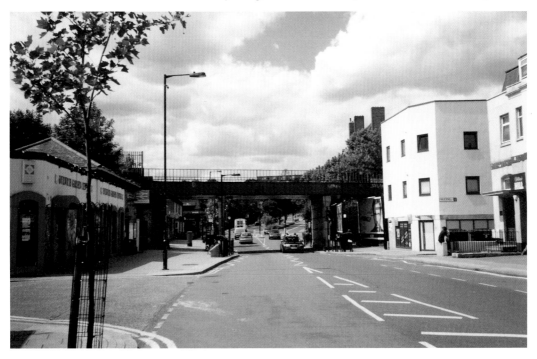

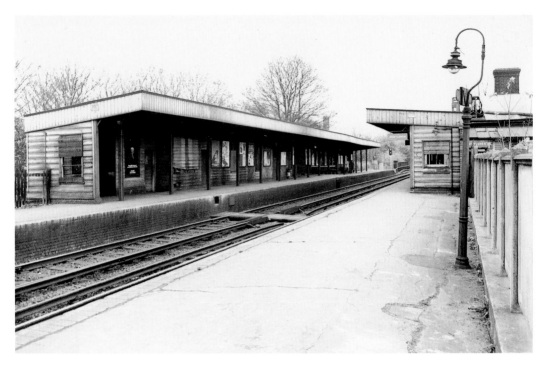

Snow in April

East Dulwich Station had a men's toilet in 1972. When the station opened in 1868 it was called Champion Hill Station. It was renamed East Dulwich twenty years later. Snow fell on East Dulwich Station on 6 April 2008 — an unusual event for that month.

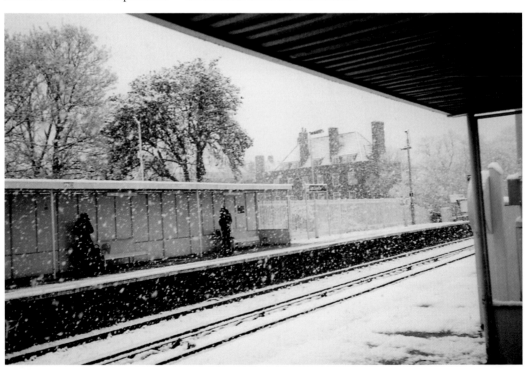

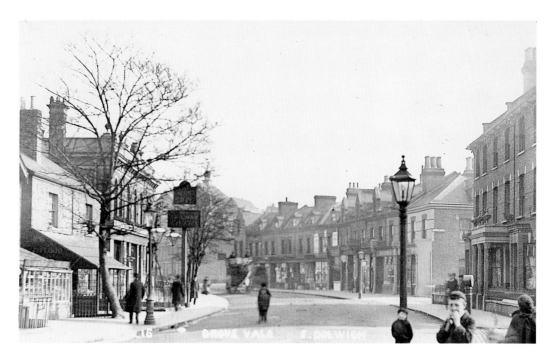

1842 Map

An 1842 map, which can be seen in the highly-acclaimed Southwark Local History Library, shows what today is Grove Vale winding between fields. A century ago Grove Vale (now Goose Green) School existed, as did the present-day houses with shops between Derwent Grove and Elsie Road. The 2009 view of Grove Vale from East Dulwich Station shows the popular Shaun's DIY shop, which is an Aladdin's cave.

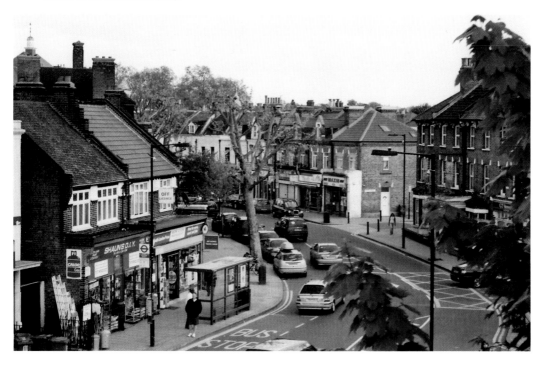

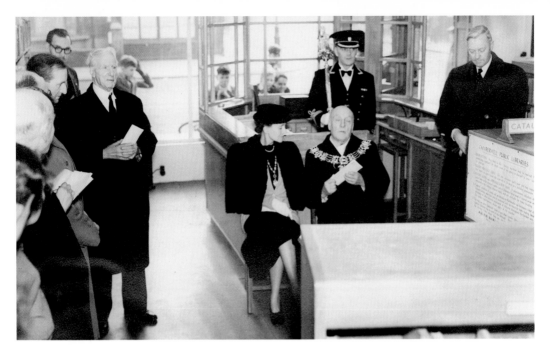

Grove Vale Library

Lord Ammon, when he was Mayor of Camberwell, opened Grove Vale Library on Saturday 28 October 1950. He said that libraries were not just places where people could borrow books but where they could obtain help and advice from skilled staff. The library had long been wanted by people living in the district and over 1,000 people applied for membership cards in the first week of registration. The junior section of the library was opened six years later. Today, the library is popular and busy, with a variety of activities. The library caters well for people in East Dulwich and the southern part of Peckham.

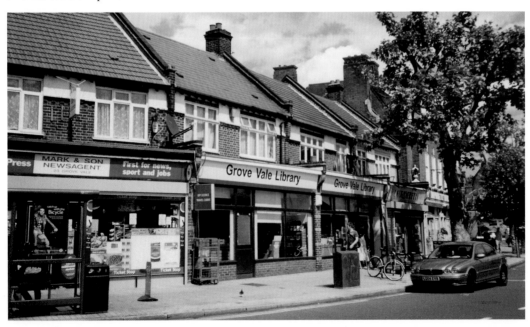

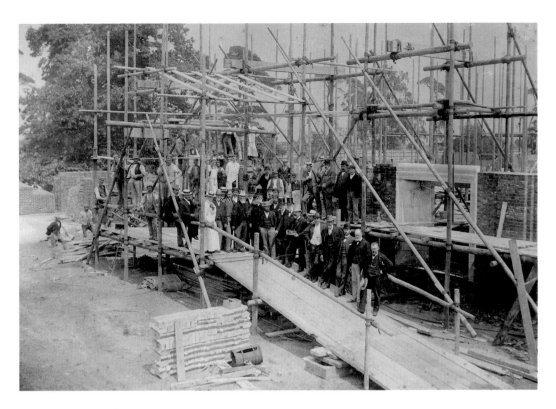

Plaquett Hall Farm

The Grove Vale Depot was built on land that had been part of Placquett Hall Farm. Besant Place and Hayes Grove were built where the Camberwell Borough Council's depot had opened in 1901. A beautiful sunset was seen on 14 November 2005. The photograph was taken from the loft bedroom at 6 Everthorpe Road and shows the top of Hayes Grove between chimneys in Copleston Road.

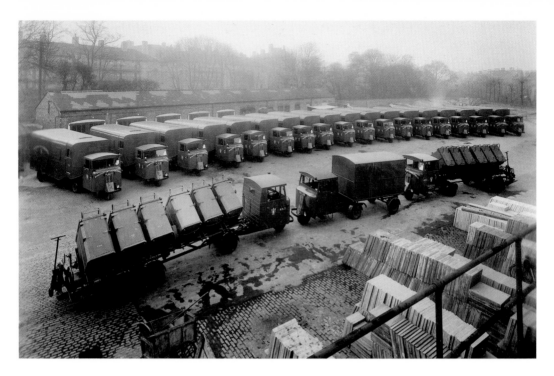

Grove Vale Depot

Camberwell Borough Council, which was established in 1900, stored its vehicles in Grove Vale Depot. After the depot closed, developers wanted to build a Homebase on the site. The Grove Vale Renewal Forum played a significant part in preventing the store from being built. Besant Place commemorates social reformer Annie Besant and Hayes Grove was named after the Surrey cricketer Ernest George Hayes, who was born in Peckham.

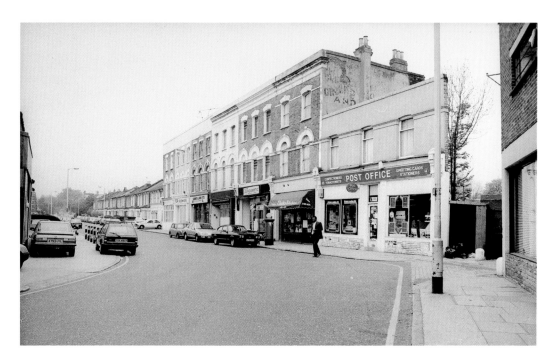

Melbourne Grove

There was a post office on the west side of Melbourne Grove in 1984, which was later transferred to the other side of the road. Though a vigorous campaign was mounted to keep it open, the post office closed in 2008. In the previous year, the number 37 bus route ceased to run along Melbourne Grove, so there was no longer a bus service connecting Peckham Rye, East Dulwich and North Dulwich Stations. For decades, buses ran along Melbourne Grove until car owners in that road successfully campaigned for a change in the route, which has greatly inconvenienced bus users, especially those who are disabled.

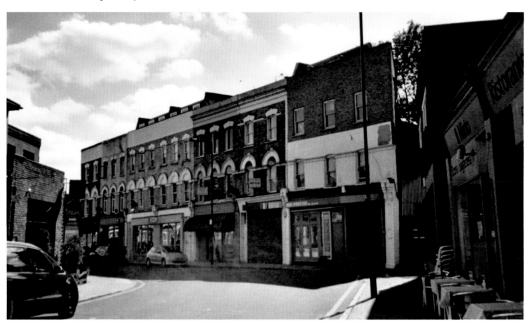

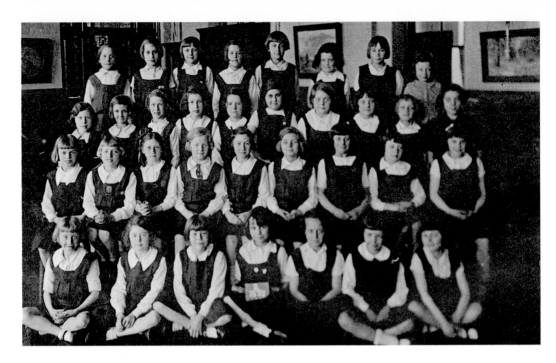

Goose Green School

The pupils at Grove Vale School were photographed *c.* 1936. The school was opened by the School Board of London in 1900 and built on former market gardens. The weather vane on top of the school is not accurate. During the Second World War, the cable from a barrage balloon knocked the south indicator off the weather vane and moved the remaining indicators so the 'N' is now pointing north-east. Goose Green Primary School opened in 2000 in the former Grove Vale School building. The photograph below shows Goose Green School from Copleston Road. On 29 August 2009 a car flipped onto its side after hitting a stationary car in Copleston Road.

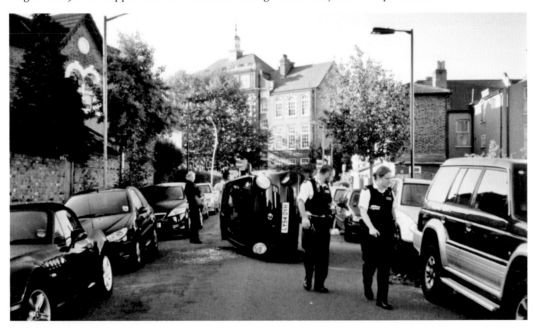

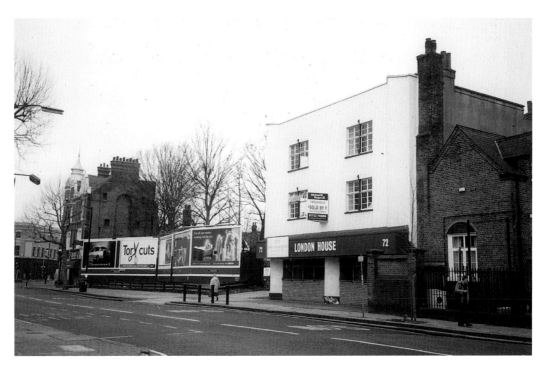

The Odeon Cinema

London House in Grove Vale was originally the Odeon cinema that opened in 1938 and had 1,288 seats. It was built on the site of Imperial Hall. The Odeon closed in 1972 and the building then became a place of worship for the followers of fifteen-year-old Guru Maharai-Ji from India and was called the Palace of Peace. The London Clock Company took over the premises in 1978. The former cinema was demolished to make way for key worker accommodation.

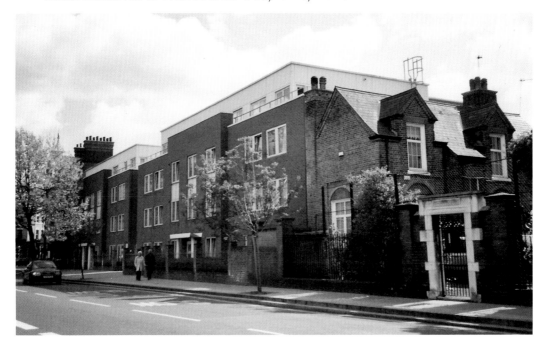

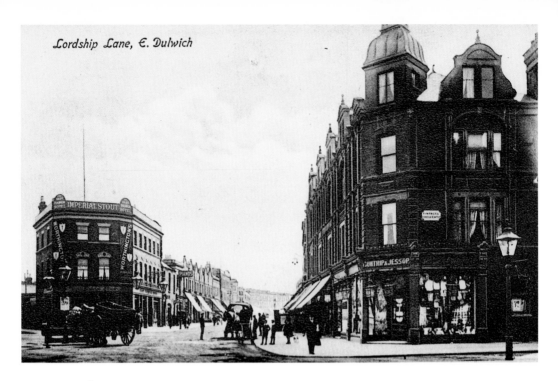

Lordship Lane, E. Dulwich

Horse Trough

A horse trough stood where the Goose Green roundabout was created after electric trams ceased running through East Dulwich in 1951. It was made from the tram setts, the granite blocks which held the lines in place. A palm tree from Chile was planted in the centre of the roundabout in 2008. Two successful campaigns have been run by local people to prevent the roundabout from being reduced in size.

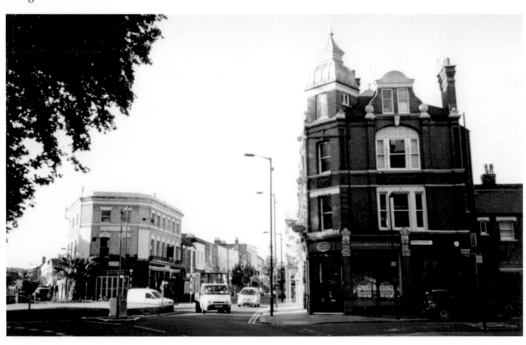

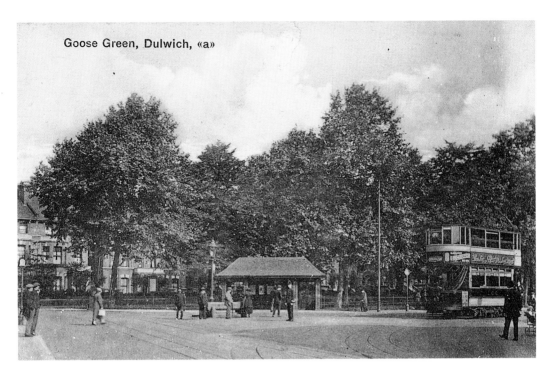

Goose Green, Dulwich, «a»

Goose Green Roundabout

A shelter used to stand close to where the Goose Green roundabout is today. A postcard showing a different picture of the shelter was posted in 1915 and reproduced in *East Dulwich Remembered*. Electric trams came to East Dulwich in 1906 when they ran along Lordship Lane to Barry Road. In 1907, a branch from Goose Green along East Dulwich Road terminated at Peckham Rye (Stuart Road).

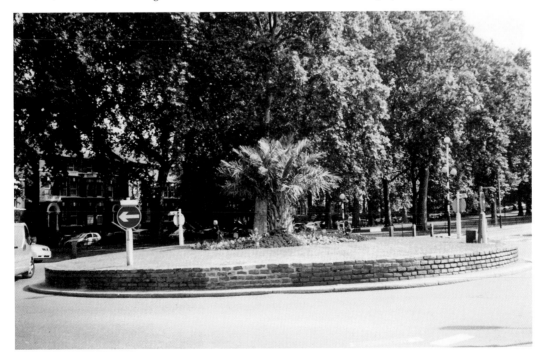

Tintagel Crescent

Though it cannot be seen in this 1984 photograph, the rear of the Odeon cinema was in Tintagel Crescent until the 1938 cinema was demolished to make way for key worker accommodation run by Broomleigh Housing Association. A thick layer of snow covered Tintagel Crescent in February 2009 and provided some residents with a view of snow on Goose Green.

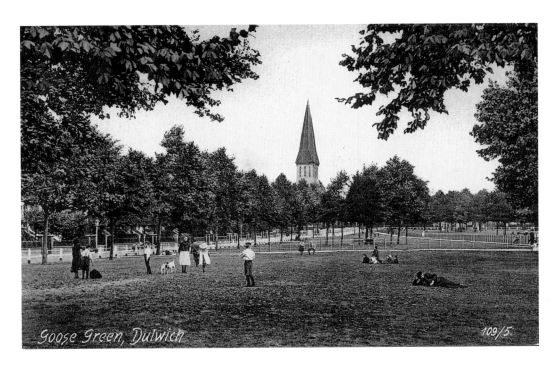

Goose Green

Goose Green was the village green for the hamlet of East Dulwich. St John the Evangelist church was consecrated in 1865. *St John's, East Dulwich, Church and Parish* was written by Mary Boast who was Southwark Council's first Local Studies Librarian in 1972. She wrote a good number of books on Southwark's fascinating history and countless people owe much to her research and writing. She won much praise for her enterprising series of Neighbourhood Histories. In 1994, Mary Boast was awarded the Freedom of the Borough, which was a remarkable and well-deserved civic honour.

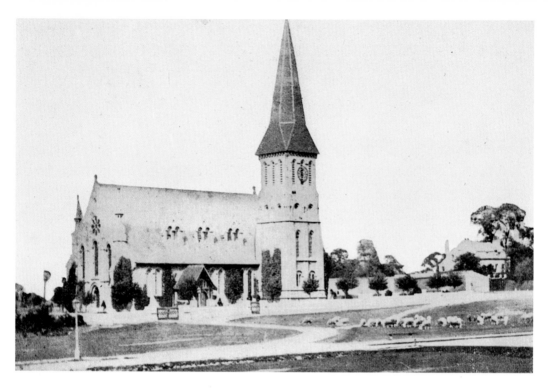

St John the Evangelist Church

St John the Evangelist church was built on 'the South East corner of the Great Field' on land given by Charles Jasper Selwyn, who was an eminent lawyer. The church was designed by Charles Baily and consecrated by the Bishop of Winchester on 16 May 1865. The photograph showing sheep on Goose Green was included in *A History of the Parish of St John the Evangelist 1865-1951* edited by W. J. A. Hahn (1951). This can be seen in Southwark Local History Library.

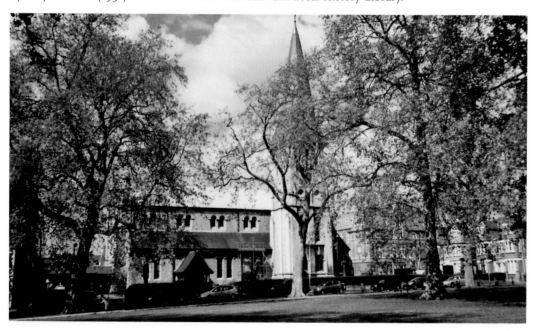

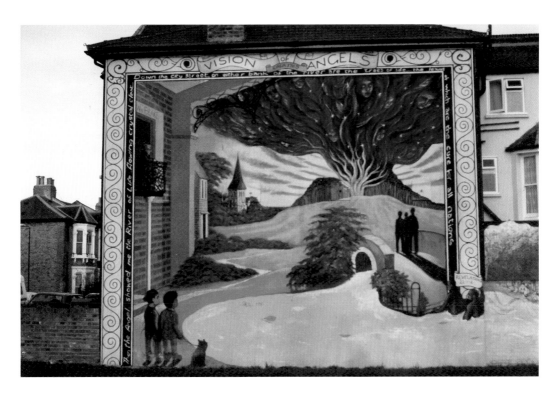

Mural

The mural 'William Blake's Vision of Angels' was painted on a wall adjacent to the children's playground at Goose Green in 1993 by Stan Peskett. He was assisted by local schoolchildren, adults with learning difficulties and other community volunteers. The mural commemorates the vision of angels that William Blake had as a child on Peckham Rye in the eighteenth century. Unfortunately, it was damaged with graffiti, but Southwark Council committed a further act of vandalism by covering a third of the attractive mural with blue paint in 2008.

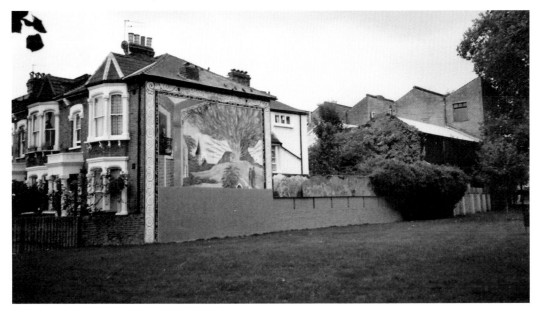

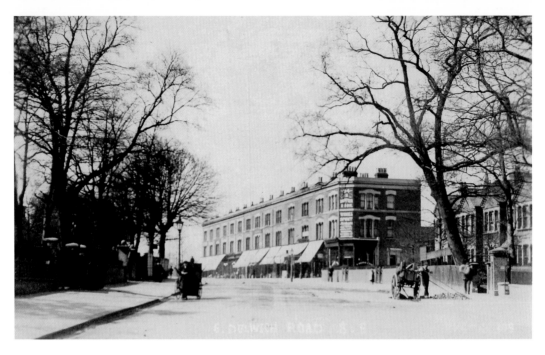

East Dulwich Road

This row of shops in East Dulwich Road, which appeared on a postcard published *c.* 1905, would have been on the cover of the Peckham tourist map if the editor of *Peckham Society News* had not objected on the grounds that they are in SE22 and not SE15. The terrace was included in *Discover the Real Peckham featuring the Bellenden Renewal Area* because the renovation of this shopping area was carried out under the artistic direction of fashion designer Zandra Rhodes.

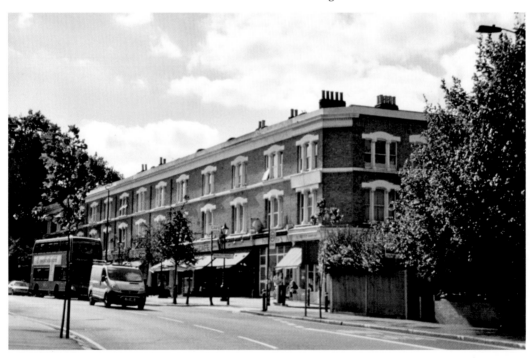

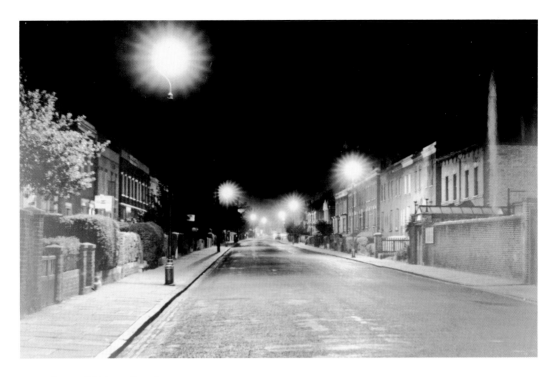

Crystal Palace Road

The General Electric Company photographed Crystal Palace Road at night in about 1936. An entrance to the Dulwich Baths can be seen on the right. The road name celebrates the transfer of the Great Exhibition hall, used at Hyde Park in 1851, to Sydenham. Horse trams ran along Crystal Palace Road to the Plough in Lordship Lane from 1896 for about three years.

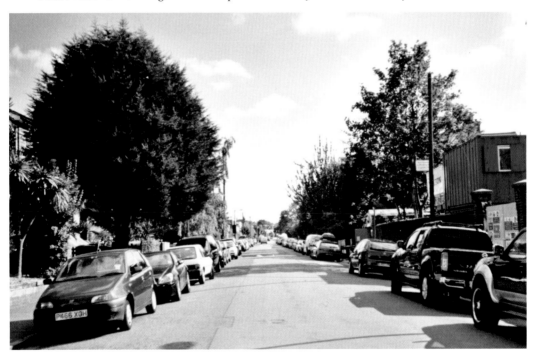

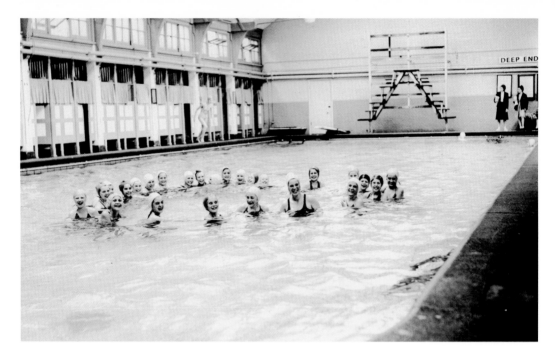

Dulwich Baths

Dulwich Baths opened in 1892; about 1,000 people attended the official opening. The building, now known as Dulwich Leisure Centre, was erected as part of a long-established movement in the nineteenth century to persuade as many local authorities as possible to build public baths and wash-houses in their areas. An informative and well-illustrated book was written by Polly Bird called *Making a Splash: The History of Dulwich Baths.* The photograph above was taken in 1953. Major renovations are taking place in 2009.

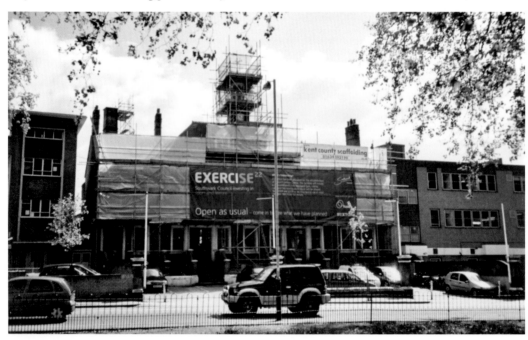

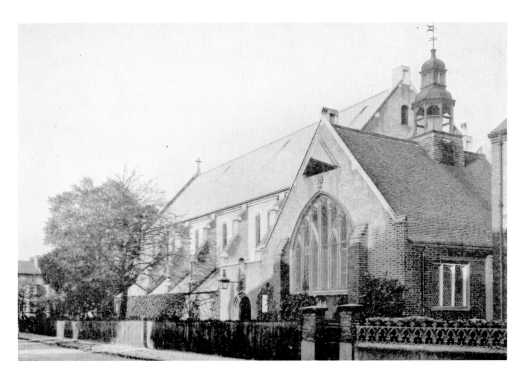

St James' Church

The Church of Scotland St James' church stood in East Dulwich Road and St James' Cloister now occupies the site. The church was opened in 1896, replacing a corrugated-iron meeting place known as 'The Tin Church'. Though the Victorian church was damaged in the Second World War, it continued to be used. The decreasing Scottish population in the neighbourhood caused its closure in 1972. The history of the church is included in *The Scots Kirk in London* by George G. Cameron.

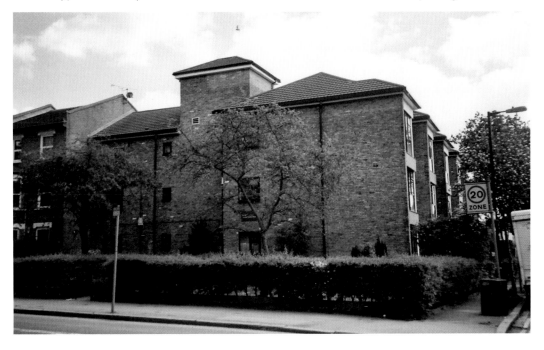

Zenoria Street

After Edwarde's electrical firm left their premises at the corner of Lordship Lane and Zenoria Street and moved to Penge, there was anger in the local community when Caffè Nero opened a coffee shop without first obtaining planning permission. The picture of snow in Zenoria Street was taken on Monday morning 2 February 2009, when so much snow fell that no buses ran anywhere in London.

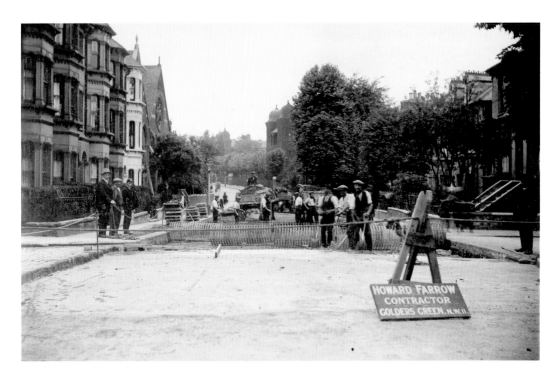

East Dulwich Grove

A new road surface was laid in 1924 in East Dulwich Grove. On the left is Dulwich Grove Congregational church and on the right there is St Saviour's Infirmary. East Dulwich Grove was built on a footpath known as Baily's Grove. This is marked on Dewhirst's 1842 map of the parish of St Giles, Camberwell, which shows its ecclesiastical and parochial boundaries. This is one of the large number of maps that the public can see in Southwark Local History Library.

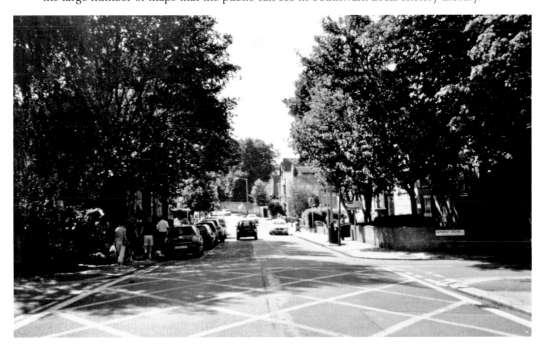

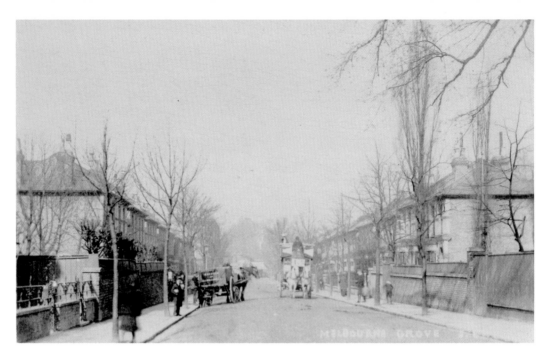

Derbyshire Colony

Melbourne Grove was part of 'The Derbyshire Colony' which W. H. Blanch wrote about in *Ye Parish of Camerwell* published in 1875. '[Mr E. J. Bailey of the Lord Palmerston Inn] having started a gigantic scheme which promises to connect with his name and the place of his nativity the greater part of a large township covering about seventy acres [of agricultural land].'

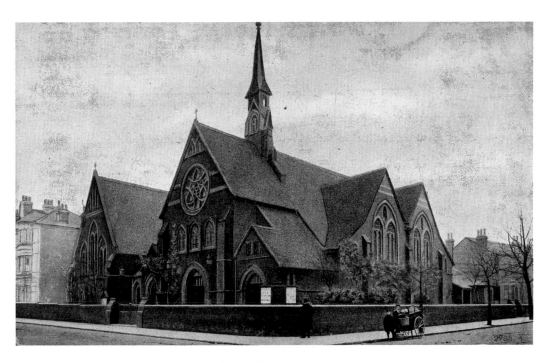

Dulwich Grove United Reformed Church

Dulwich Grove United Reformed church was originally a Congregational church and was opened in 1890, with the Lecture Hall opening eleven years earlier. An oil bomb made a direct hit through the roof on 12 September 1940. Though it did not ignite, gallons of sticky black oil were scattered over the organ, pulpit and pews. A block of flats in Camberwell called Gwen Morris House commemorates a member of the church who became a missionary in China and India.

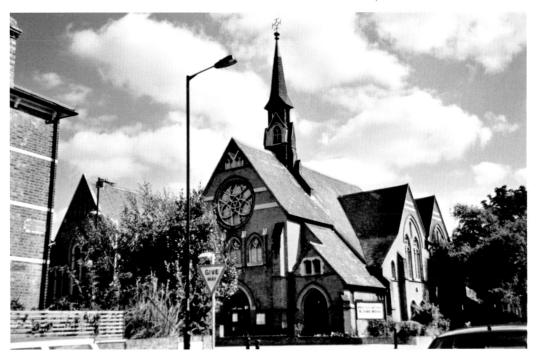

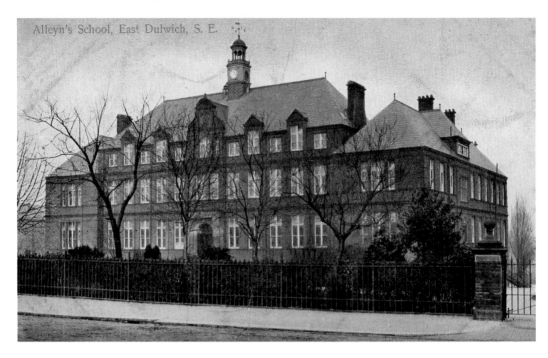

Alleyn's School

Alleyn's School was opened in 1887 to house the Lower College of God's Gift. The school included sixteen classrooms, offices, kitchens and servants' quarters but it had 'no gym and the field was a wilderness where the pheasant waged incessant war on the mangel-wurzel'. The cost of the new building was £13,805. The story of the school is told in *Alleyn's The Coeducational School* by Arthur R. Chandler.

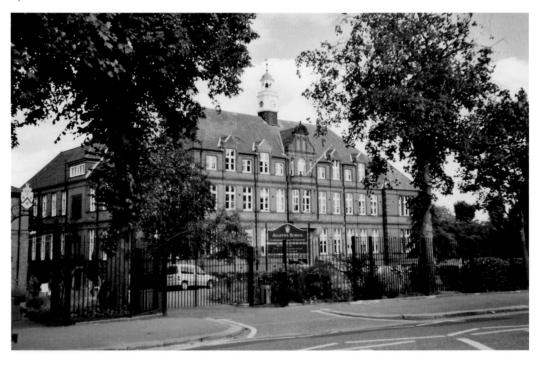

Presbyterian Church

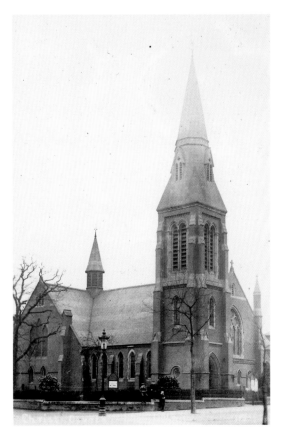

Christ Church Presbyterian church stood at the corner of East Dulwich Grove and Townley Road. It was designed by Charles Barry Junior and the foundation stone was laid on 4 July 1890 by Sir Donald Currie, MP. The church was opened for worship on 21 December 1890, closed in 1938, and was demolished in 1965 or 1966. Nine houses were built on the site. The Beeches, 179 East Dulwich Grove, was the church's parsonage.

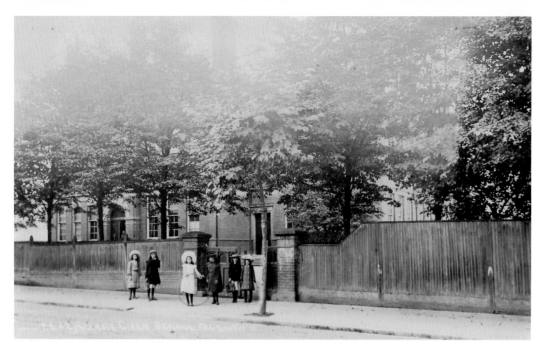

James Allen's Girls' School

James Allen's Girls' School is believed to be the second oldest girls' school in London. It was founded in 1741 and started in two rooms in the Bricklayers Arms, later called The French Horn, in Dulwich village. The school has been known by its present name since 1878 and moved in 1886 to the present site. The country's first school laboratory equipped solely for botanical study was established here in 1902. Local historian Brian Green wrote *To Read and Sew ... James Allen's Girls' School 1741-1991.*

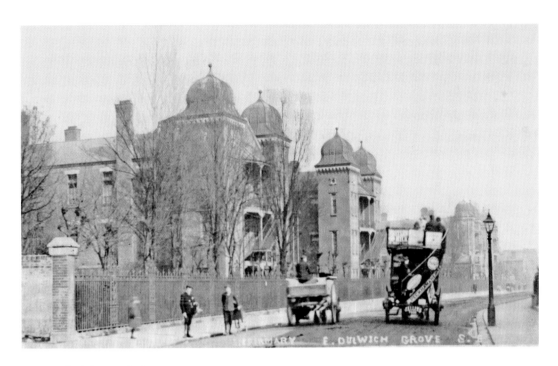

Dulwich Hospital

There was much opposition to St Saviour's Infirmary being built. It opened in 1887 and became Dulwich Hospital in 1930. In recent years there have been campaigns to prevent it from being closed. The building was originally an infirmary for parishes in what became the Metropolitan Borough of Southwark. During the First World War, it became Southwark Military Hospital; over 14,000 casualties were admitted.

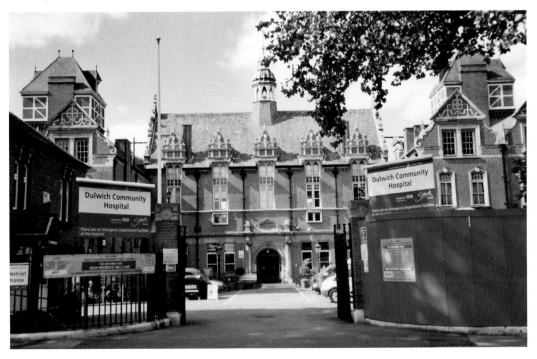

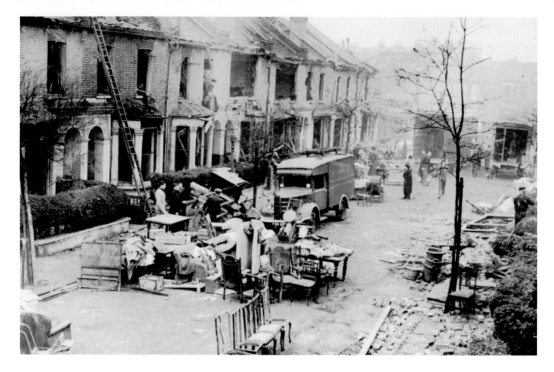

Lytcott Grove

Lytcott Grove and Playfield Crescent, which were hit in the same raid, were rebuilt after the Second World War. In *Around Dulwich* Brian Green wrote that Lytcott Grove (originally built in 1879) commemorates 'the tragic Dulwich family who perished in the plague. Almost three hundred years later, on the night of 17th January, 1943, the little road had a tragedy of its own. A party was in progress in one of the houses and there had been little or no bombing for almost two years. That night the Luftwaffe mounted a reprisal raid for the Royal Air Force's bombing of Berlin'.

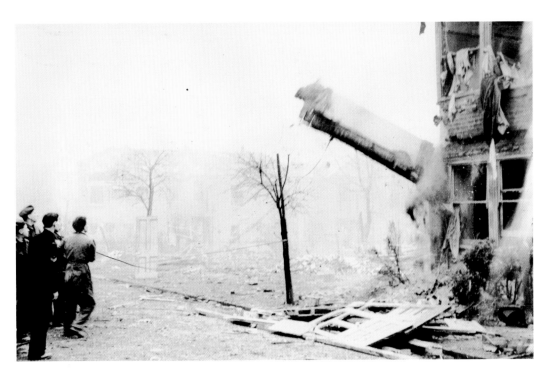

Playfield Crescent

After German Luftwaffe reprisal raids on 17-18 January 1943, Civil Defence workers pulled down a dangerous building in Playfield Crescent. The raids on East Dulwich, in which people were killed or died from their injuries, are recorded in *'There Are No Winners'* — *The Raids on Southwark 1940-1945* compiled by John Hook. It can be seen in the excellent Southwark Local History Library.

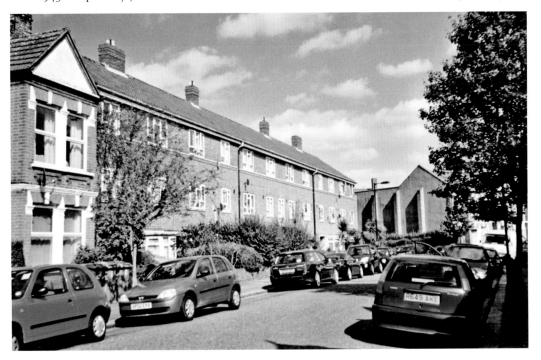

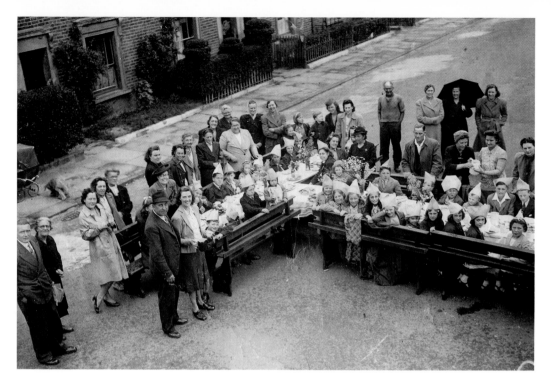

Frogley Road

A street party was held in Frogley Road; possibly to celebrate V.E. Day. When Frogley Road was surveyed in 1899 on behalf of Charles Booth, George Arkell and PC 'Taffy' Jones reported: 'Two families. Labouring people, sweep etc. Some broken windows.' *The Streets of London: The Booth Notebooks - South East* states: 'PC Jones is a big beefy man of 40 with a full, jolly-looking face and a fund of humour and contentment that nothing can disturb. He is a Norfolk man and has had 17 years of service in the East and West Dulwich sections.'

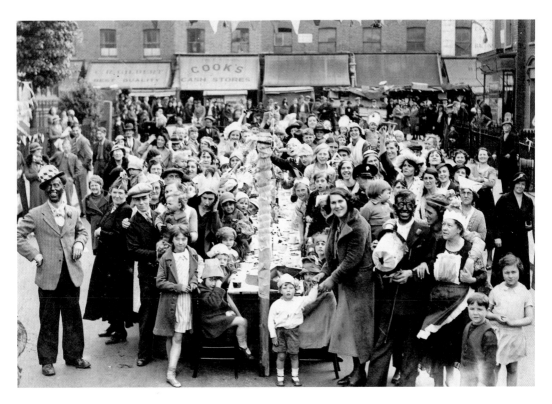

Nutfield Road

Nutfield Road residents celebrated the Silver Jubilee of George V in 1935. Some of the shops in North Cross Road were destroyed in the Second World War, as were nearby houses in Nutfield Road and the shop on the corner, which provided a laundry receiving service.

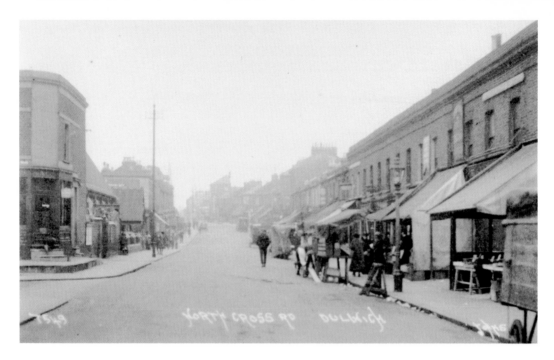

North Cross Road

North Cross Road took its name from a plot of land in Dulwich called North Crofts. When the road was surveyed in 1899 for Charles Booth's seventeen-volume survey *Life and Labour of the People in London,* there was 'a poor class of 2-storey shops on the south side'. This early twentieth-century view shows stalls in the road. On the left is Nutfield Road. Some Victorian shops and houses no longer exist because they were damaged by bombs dropped in the Second World War.

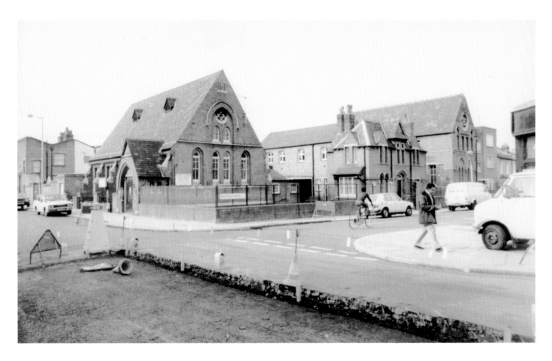

St John's School

St John's and St Clement's School, seen here in 1982, began in 1829 in the basement of East Dulwich Chapel, which was on the west side of Lordship Lane facing Goose Green. The school later moved to Troy Town near the northern part of Peckham Rye Common. In 1872, it transferred to North Cross Road where it remained until 1994 when it took over the former Adys Road School. The school at the corner of North Cross Road and Archdale Road was converted into apartments called St Clement's Yard.

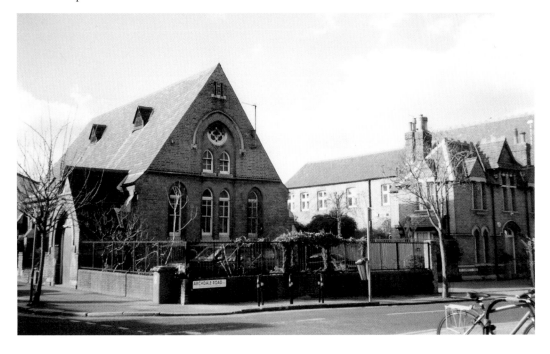

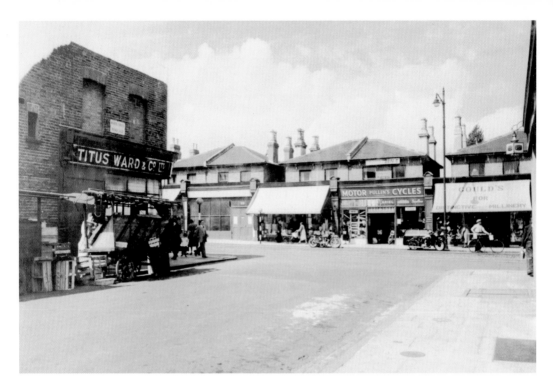

Market Stalls

Market stalls have been a feature of North Cross Road for many years, as this 1948 picture shows. Bomb damage from the Second World War can be seen on the wall that was part of Titus Ward's shop.

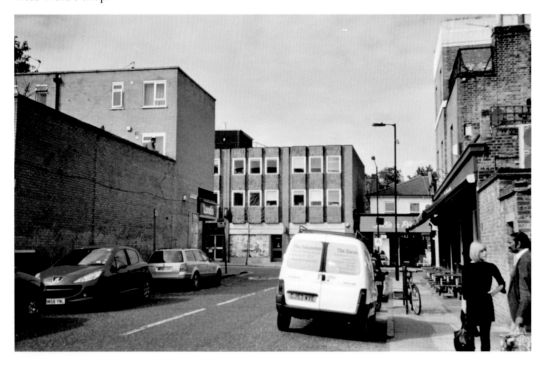

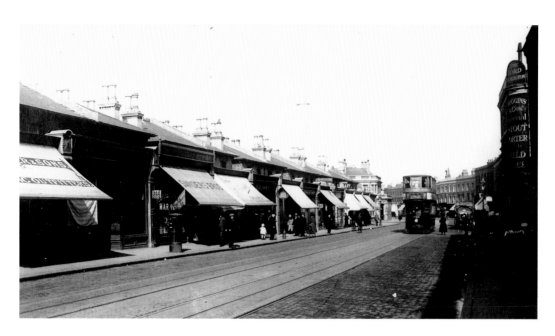

Lordship Lane

Lordship Lane is shown on Dewhirst's 1842 map of the parish of Camberwell. Electric trams started running along this road in 1906. Lordship Lane has always been the main shopping street for East Dulwich. Next to Alfred Chandler (athletic outfitters), on the far left of picture, was a post office at number 90; the present post office is at numbers 74 and 76.

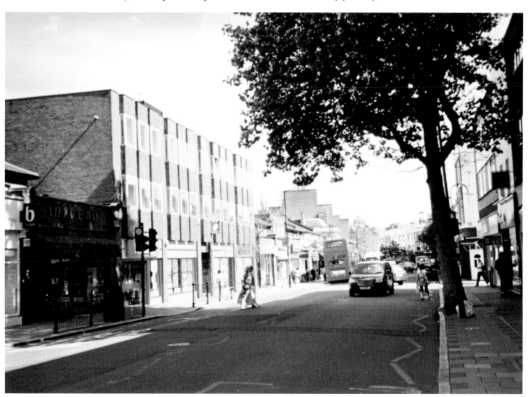

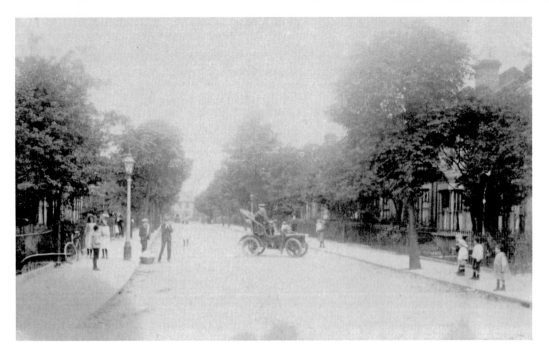

Chesterfield Grove

Chesterfield Grove was one of the roads built in the nineteenth century by Ezekiel James Bailey, who was a native of Derbyshire. He lived in Rosedale Villa, Lordship Lane. On his own freehold estate lying south-west of Goose Green he built, or contracted to have built, nearly 400 houses on this and the adjoining estates between 1871 and 1878.

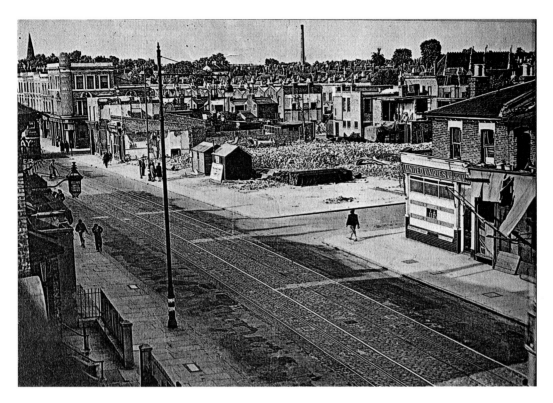

Co-operative Store

A bomb destroyed the Royal Arsenal Co-operative Society's store at 111-115 Lordship Lane and neighbouring shops in 1944. Many people were in the shops and others were waiting at a tram stop. Twenty-three people were killed and a further forty-two were seriously injured. The Co-operative store was rebuilt but that closed soon after Sainsbury's store at Dog Kennel Hill opened. The pharmacy closed in 2009.

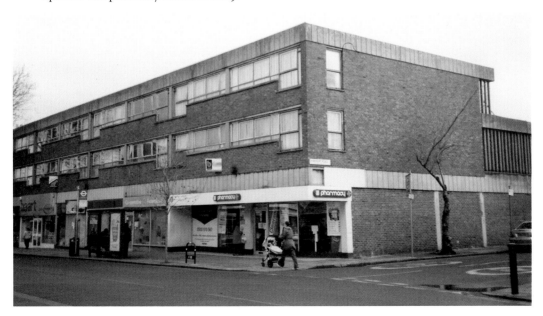

Bassano Street

Bassano Street was photographed in 1984, a century after it was built. Several pictures in Dulwich Picture Gallery are described as 'Copies after Bassano' (i.e. Giacomo da Ponte Bassano, Venetian painter, 1510-92). The Church of God (Seventh-Day) Sabbath Keeping Temple uses the former Church of the Epiphany, which belonged to St John the Evangelist, Goose Green. After that church was badly bombed in the Second World War, services were held in the Bassano Street building.

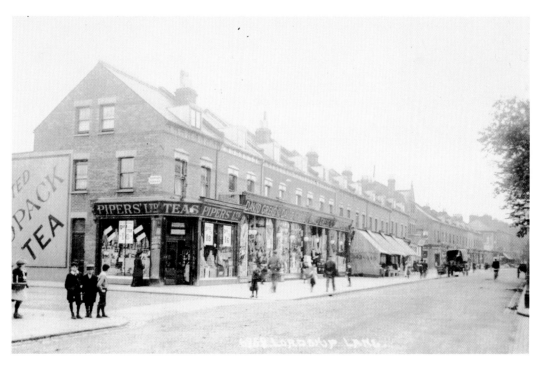

David Greig

David Greig, a firm that sold groceries, had a shop near Hansler Road. The firm's name can still be seen in the doorway of another of their former shops at 65 Lordship Lane.

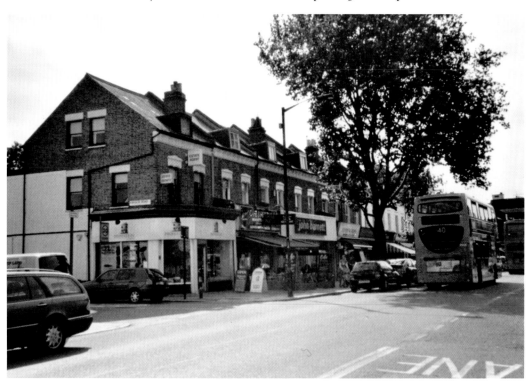

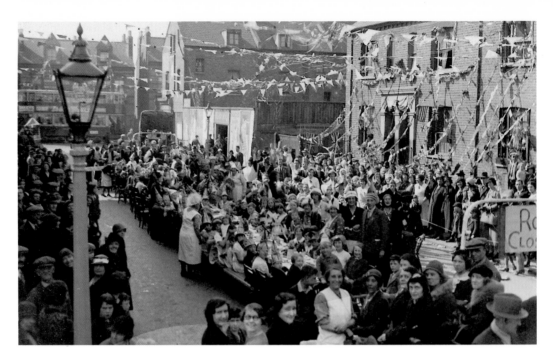

Whateley Road

A street party was held in Whateley Road in 1937 to celebrate the Coronation of George VI. The road commemorates Richard Whately (1787-1863), an English theological writer who became Archbishop of Dublin in 1831. It is one of several roads in the neighbourhood named after bishops. Whateley Road was built in 1886.

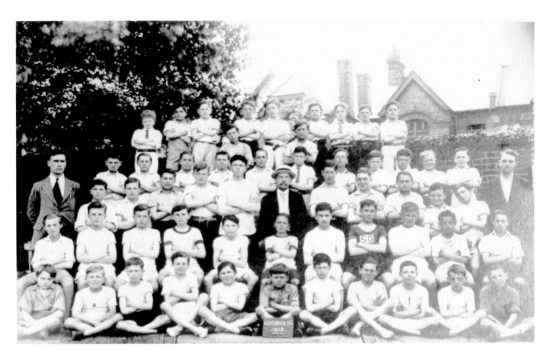

Goodrich School

Goodrich Primary School was designed by E. R. Robson, the first architect to the School Board of London, and opened in 1886. The picture above shows the prize winners in the 1923 school sports. Edgar Kail, the most notable Dulwich Hamlet Football Club player, was a pupil at the school. The school can be seen from Dawson's Heights.

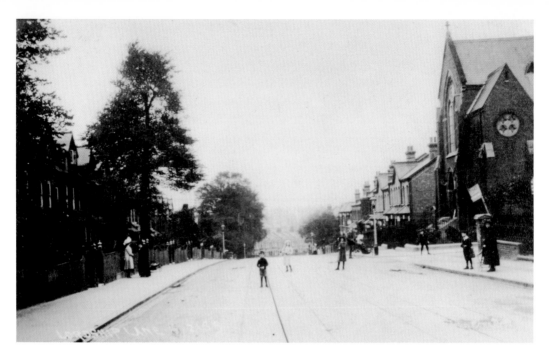

Lordship Lane Baptist Church

This photograph was taken before trams began running along Lordship Lane beyond Barry Road in 1908. Lordship Lane Baptist church opened in 1873 to accommodate a thriving congregation that had been meeting in an iron church. Seven people attended the first service during a stormy evening in December 1869. The present building was seriously damaged in 1944 when a flying bomb fell on 234 and 236 Lordship Lane.

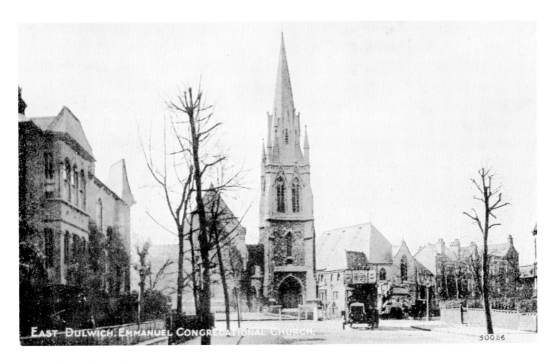

Christ Church

Emmanuel Congregational church in Barry Road is now a hostel called Barry House. The stone church opened in 1891. The hall next to the former Victorian church is now Christ Church, a joint United Reformed and Methodist Church. It includes a café for the public and a shop selling Fairtrade products.

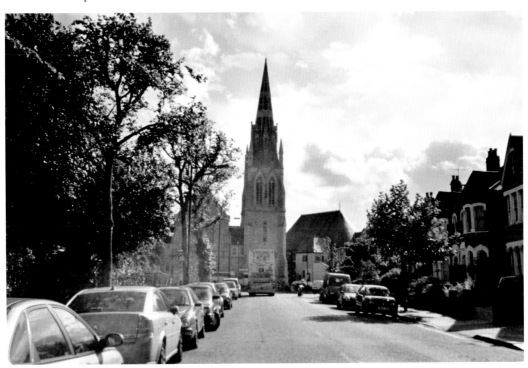

Barry Road

Barry Road commemorates Sir Charles Barry (1795-1860) who was the architect of the Houses of Parliament. No fewer than forty-nine different builders were involved in house construction in Barry Road. When the road was surveyed in 1899 for Charles Booth's survey, many of the residents had servants. The road is slightly less than a mile long.

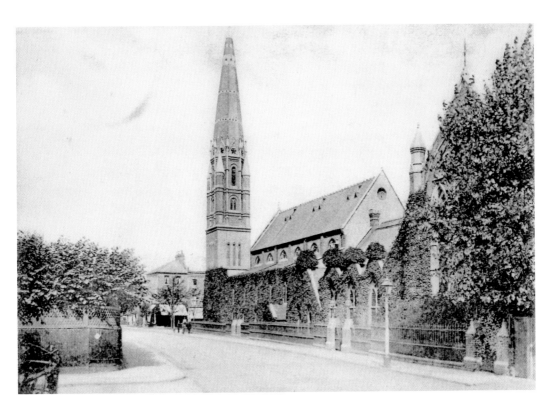

Barry Road Methodist Church

Barry Road Methodist church stood where Dorothy Charrington House is today. The church opened in 1874 and a lecture hall was built in 1880. The Revd Hugh Price Hughes was minister (1878-81). He was a leading figure in Victorian Methodism and was editor of the *Methodist Times*. The congregation amalgamated in 1988 with the nearby United Reformed Church and meet in Christ Church, further up Barry Road.

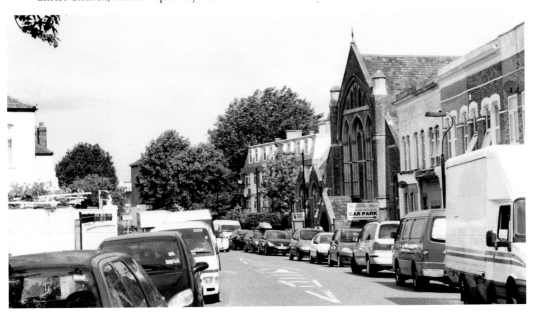

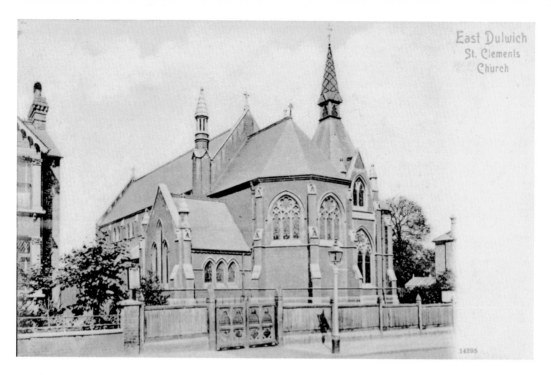

14295

St Clement's Church

St Clement's church in Friern Road was consecrated by the Bishop of Rochester in 1885. It was named after a bishop of Rome who died about AD100. The church was paid for by Francis Peek, a city merchant. After the Victorian church was bombed in 1940, the hall in Barry Road became a temporary church for seventeen years. The present church, now called St Clement with St Peter, Dulwich, was consecrated in 1957.

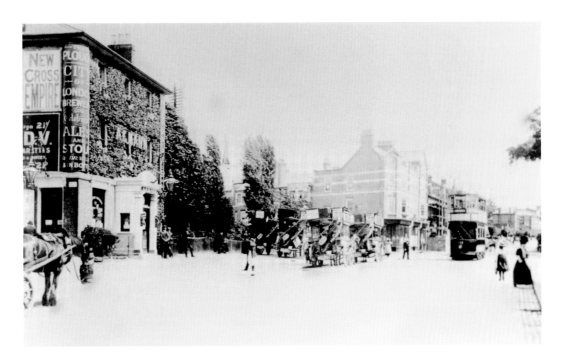

Plough Inn

In *Ye Parish of Camerwell*, published in 1875, W. H. Blanch included a drawing of the original Plough Inn. He stated that it 'was once an old-fashioned wood structure — a noted place of resort for the lads and lasses of the great city. It was leased for sixty-one years in 1805 to Mrs Ann Reynolds by Joseph Windham Esq., at an annual rent of £12. It was afterwards carried on by Mr W. Coombs, by whom the new "Plough" was erected.' The present building dates from 1865.

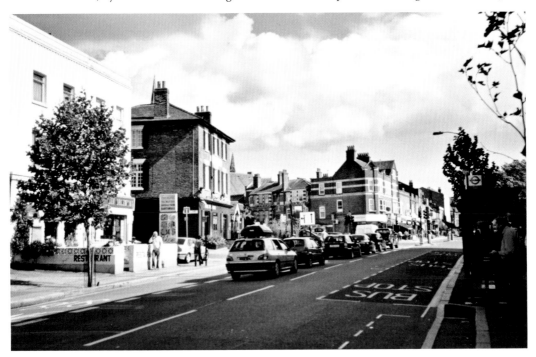

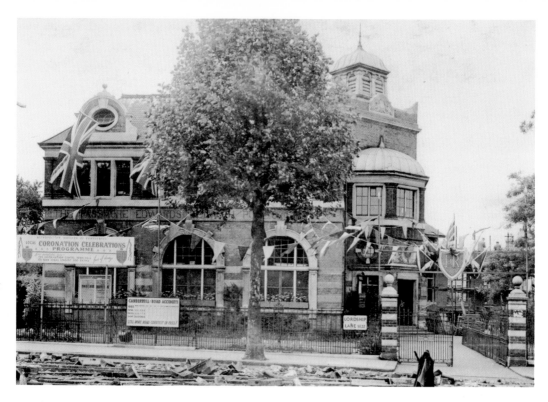

Dulwich Library

Actor Sir Henry Irving laid the foundation stone of Dulwich Library, which was opened by Lord Halsbury in 1897. A bomb hit the library in 1940, so after the war an extension was built. This included a junior library and a hall .The library was decorated for the coronation of Elizabeth II in 1953. A helicopter ambulance landed in Dulwich Library Gardens on 2 February 1996.

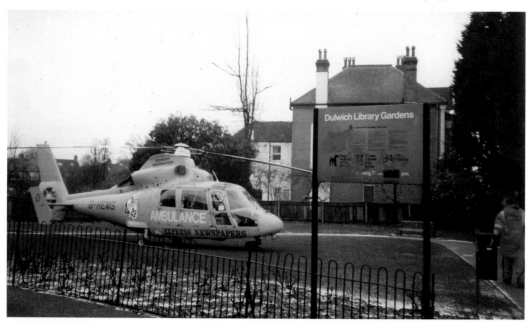

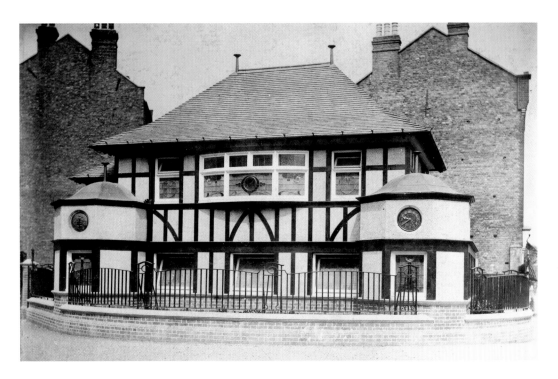

Public Toilet

This impressive public toilet, which opened in 1905 or 1906, stood opposite Dulwich Library and was known as Lordship Lane Chalet. Camberwell Borough Council decided, in March 1906, that it would close at 11.05 p.m. because that was the latest time it had been used since it opened. The council's minutes are available for the public to read in Southwark Local History Library. The toilet was damaged during the Second World War. A bank now occupies the site.

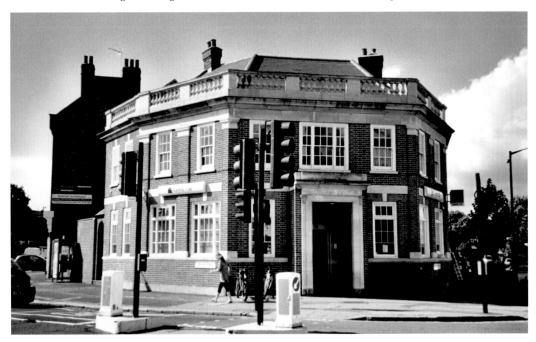

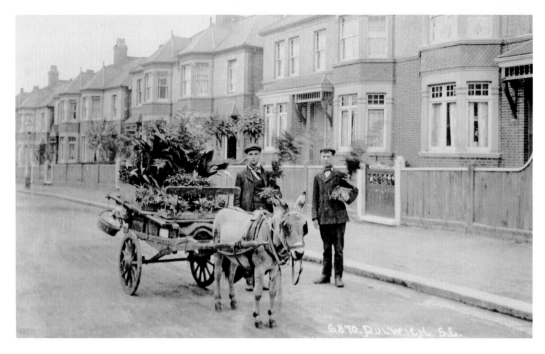

Eynella Road

In Eynella Road plants were sold from this cart pulled by a donkey early in the twentieth century. This short street was made on the track of an old footpath from the Plough Inn to Dulwich. The name is back slang for Alleyn(e) — Edward Alleyn was the founder of Dulwich College.

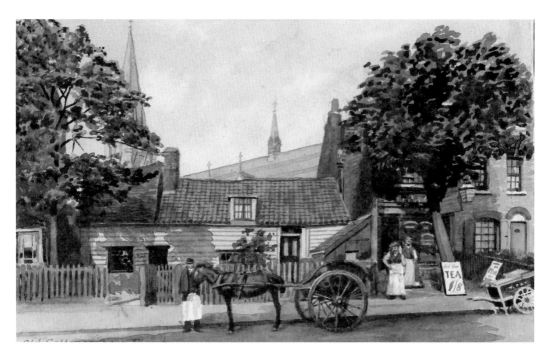

Painting

In 1923, artist E. A. Phipson painted old cottages opposite Dulwich Library. The water-colour was based on an earlier photograph of the same scene that can be seen in Southwark Local History Library, which has a collection of local scenes painted by artists who lived locally. Unfortunately, it is not possible to date the painting exactly. Frederick Pay's shop is included in *Kelly's London Suburban Directory* for 1884. Emmanuel Congregational church behind the cottages in Barry Road was opened in 1891.

Old Houses

Two old houses stood in Lordship Lane between Barry Road and Friern Road. They were on land belonging to Friern Manor Farm and were pulled down in about 1895. Their exact location is not known.

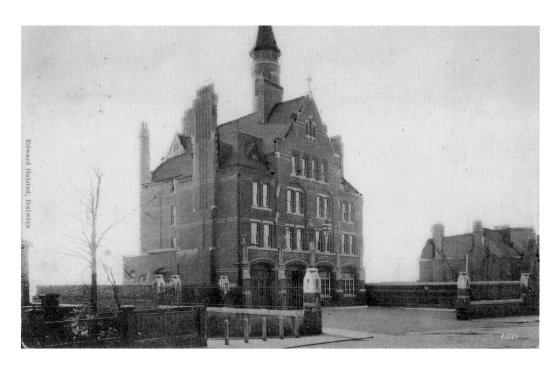

Dulwich Fire Station

Dulwich Fire Station in Lordship Lane was opened in 1893. In *Victorian & Edwardian Dulwich* Brian Green wrote that it 'accommodated 10 firemen (all married men) and four horses. The appliances were a steamer; one manual engine and four fire escapes. It took 25 seconds from an alarm being raised to the departure of the appliance.' The fire station was severely damaged during the Second World War and was closed in 1947. It was demolished in 1958 and a telephone exchange was built on the site. Fireman's Alley is a reminder of the site's history.

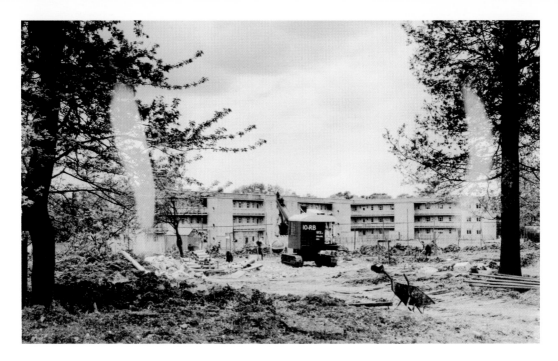

Lordship Lane Estate

The Lordship Lane Estate was under construction in 1951. The Official Souvenir Handbook to celebrate the golden jubilee of the Metropolitan Borough of Camberwell, published the previous year, stated that since the end of the Second World War the council had acquired about seventy-four acres of land as sites for permanent housing. The aim was to provide about 1,740 dwellings with accommodation for over 6,000 people. This scheme included the building of the Lordship Lane Estate.

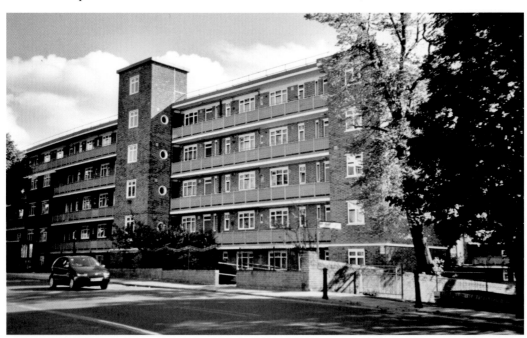

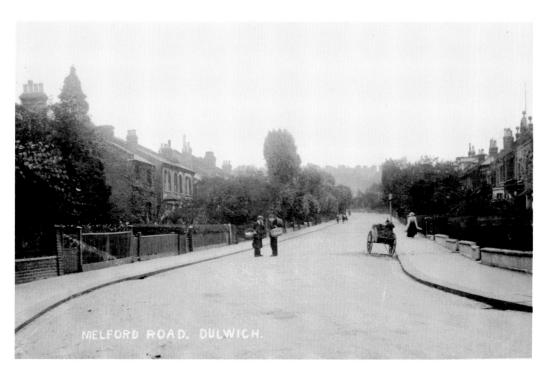

Melford Road

How different was the scene in Melford Road *c.* 1909 compared with 2009! When the road was built in 1866 it included Melford Cottages.

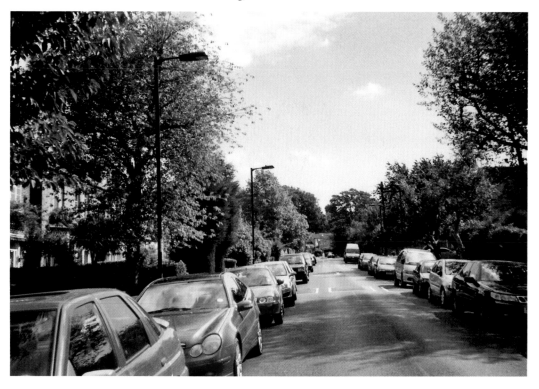

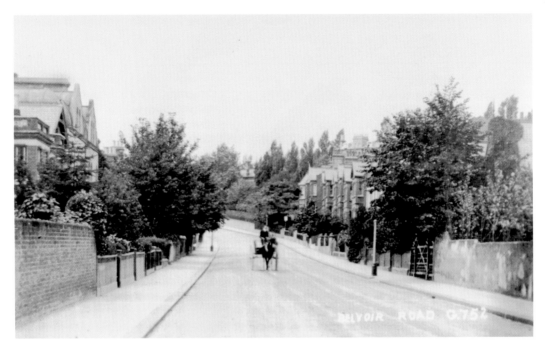

Belvoir Road

Belvoir Road, which runs between Overhill Road and Underhill Road, was originally a number of named villas, before being given its present name in 1869. One was called Belvoir Villas. The others were Melrose Villas, Heather Lee Villas, Minnie Villas, Cruickshank Villas and Trocadero Villas.

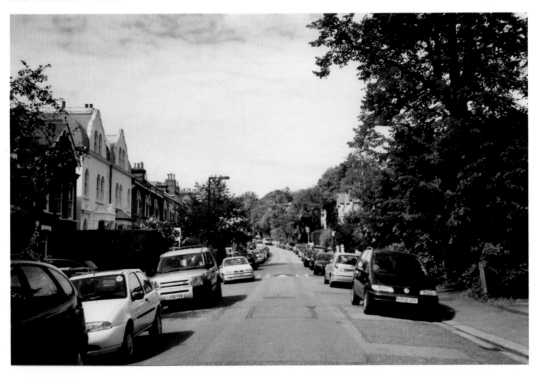

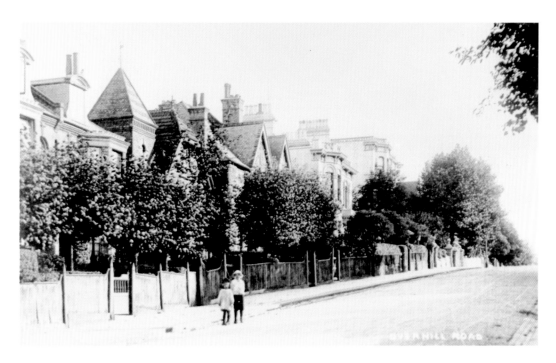

Overhill Road

Overhill Road, seen above in *c.* 1905, was named in 1867. Victorian houses were demolished so that Dawsons Heights could be built. This was named after Dawson's Brick and Tile Manufactory, which occupied much of the site. An article in *The Architect's Journal* dated 25 April 1973 gives a detailed description of the 'spectacular hilltop site'. This can be seen in the highly regarded Southwark Local History Library.

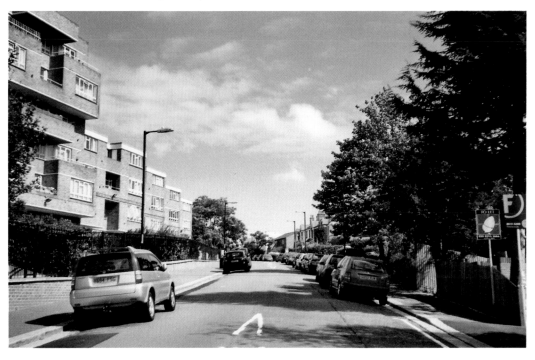

Dr Glennie's Acadamy

Dr Glennie's Academy was built on the site of The Green Man where the Harvester is today. The school's most famous pupil was Lord Byron (1788-1824). Other pupils included Major-General John Le Marchant (1766-1812), who was killed at the battle of Salamanca; Sir Donald McLeod (1810-72), who was Lieutenant-Governor of the Punjab; and Robert Barclay Allardice (1779-1854), commonly known as Captain Barclay, who was noted for his walking feats including walking one mile in each of one thousand successive hours.

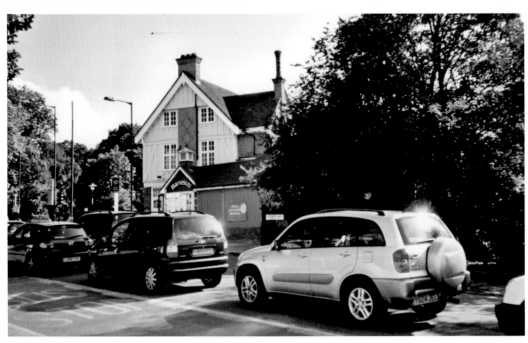

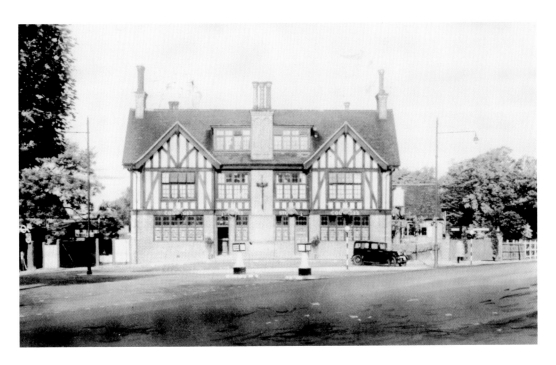

Grove Tavern

Grove Tavern, now the Harvester, was built on the site of The Green Man, which was a noted house of entertainment in the reign of George II. When East Dulwich was being developed in the nineteenth century, building land was usually sold at auctions held at local public houses, and the Grove Tavern was a favourite venue.

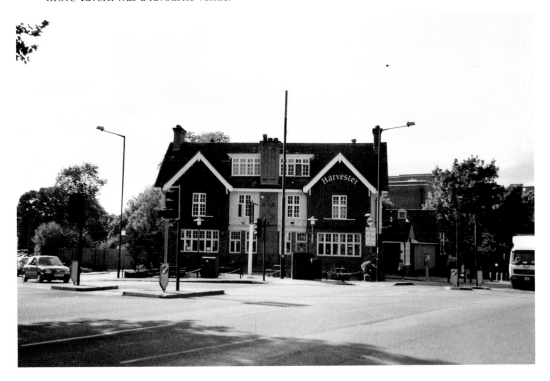

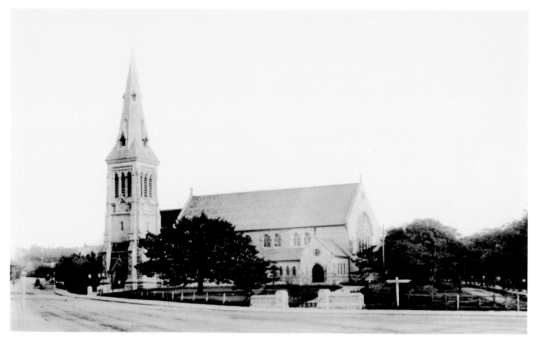

St Peter's Church

St Peter's church was built in 1874 for a congregation of 700 and is now used by the Deeper Life Bible church. The architect was Charles Barry Junior. In *Ye Parish of Camerwell,* published in 1875, W. H. Blanch gives a long description of the church, which was incomplete when the book was being written. Before the church was built, the congregation made use of an iron church on the other side of Lordship Lane. This was described as 'overpoweringly hot in summer, piercingly cold in winter, and deafening in windy weather'.

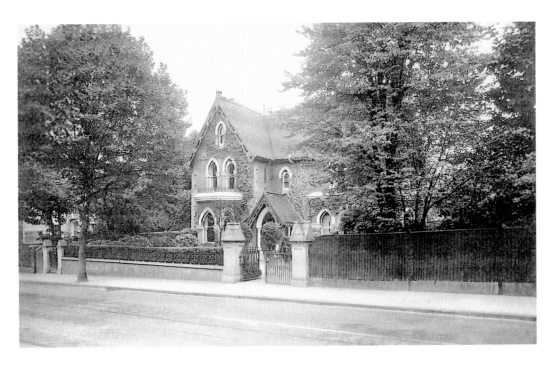

Concrete House

The derelict house at 549 Lordship Lane is an important listed building. It was built in 1873 by Charles Drake of the Patent Concrete Building Company. In 1867, Charles Drake patented his own method for building with concrete. He used sheet iron panels instead of timber shuttering. The house in Lordship Lane is a rare example of a nineteenth-century concrete house. There is no other known property of this type and of the same architectural style in England today. Southwark Council deserves congratulations for taking action that will save this significant part of East Dulwich's heritage.

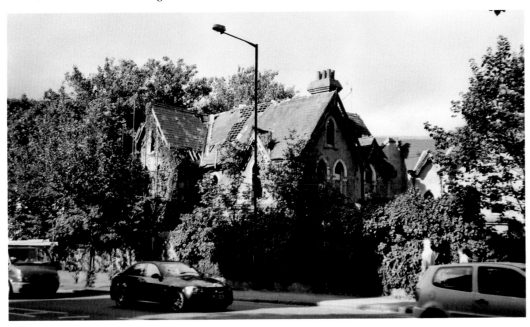

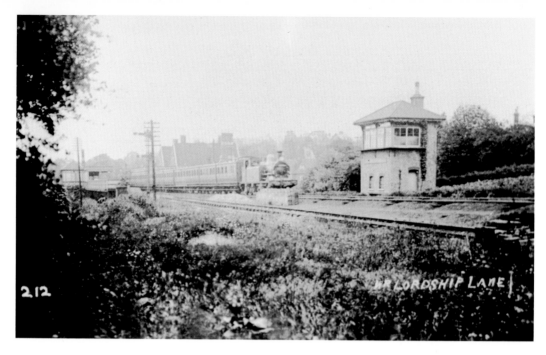

Lordship Lane Station

Lordship Lane Station opened in 1865. It was on a line from Nunhead to Crystal Palace (High Level) Station and closed in 1954. The station was painted in 1871 from the old Cox's Walk footbridge by the French impressionist artist Camille Pissarro. The painting is owned by the Courtauld Gallery, Somerset House. The view from the present footbridge in summer 2009 was totally obscured by trees and plants.

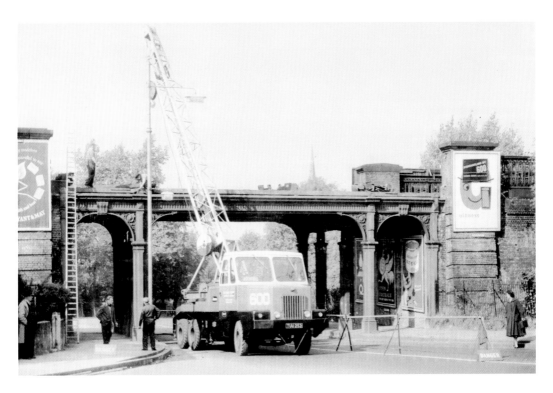

Railway Bridge

The railway bridge at the southern end of Lordship Lane, where it becomes London Road, was demolished in 1958. This was four years after the railway to Crystal Palace High Level Station had closed. It had been built to serve the Crystal Palace, which was destroyed by fire in 1936. The spire that can be seen in the picture is of St Peter's church.

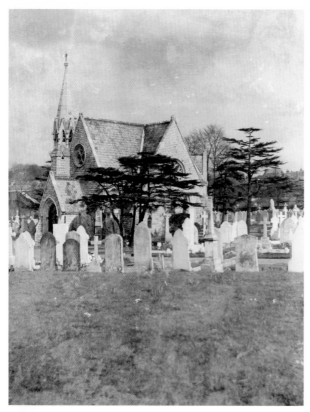

Camberwell Old Cemetery
Camberwell Old Cemetery opened in 1856 and included three chapels. The Nonconformist (shown above) and the Church of England chapels were designed by George Gilbert Scott, who was the architect of St Giles' hurch in Camberwell Church Street. The cemetery also had a Roman Catholic chapel. A large Gothic lodge is the only cemetery building that still exists. *Camberwell Old Cemetery — London's Forgotten Valhalla: A Brief History of Camberwell Old Cemetery and Who's Who of Notable Persons Buried There* was written by Ron Woollacott.

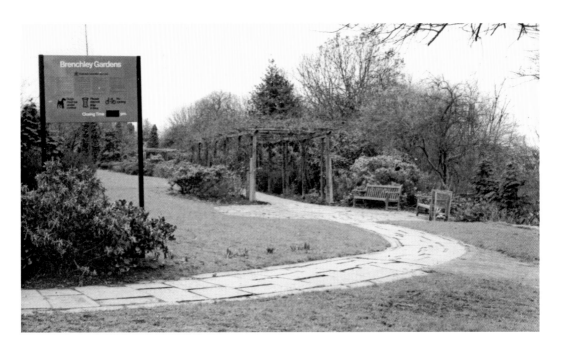

Brenchley Gardens

Brenchley Gardens were opened in 1928 by the Mayor of Camberwell, Councillor H. C. Thompson. Allotments occupied the land prior to the gardens being created. After the adjacent railway tracks were removed in 1956 the gardens were extended. They were named after Alderman William Brenchley, who was born in Stepney but spent almost fifty years in public service in Camberwell. He was a member of the Camberwell Vestry before the Camberwell Borough Council was established in 1900. He was elected to serve on the new Council and was Mayor of Camberwell 1911-12. He was a teacher by profession and taught at Bellenden Road School, Peckham. He died in Dulwich Hospital in 1938, aged 80.

Road Dug Manually

Brenchley Gardens — the road between One Tree Hill and the gardens, which were opened in 1928 — was manually dug three years earlier so that the maximum gradient was not more than 1 in 20.

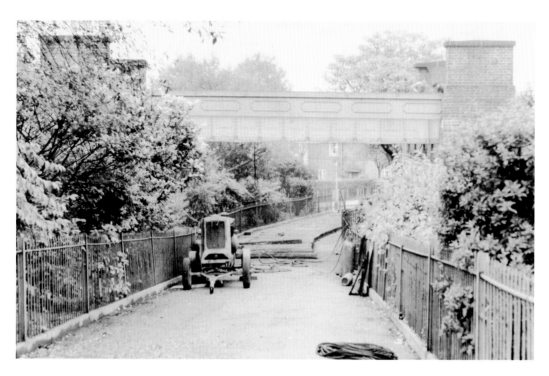

Railway Bridge

The railway bridge across Kelvington Road was removed in 1958. Steam trains had run from Nunhead to Crystal Palace (High Level) Station from 1871 until 1954. The public park known as Brenchley Gardens was extended after the tracks were taken up. The story of the railway was told in *From the Nun's Head to the Screaming Alice — a green walk along the old Crystal Palace (High Level) Railway*, published by the Friends of the Great North Wood.

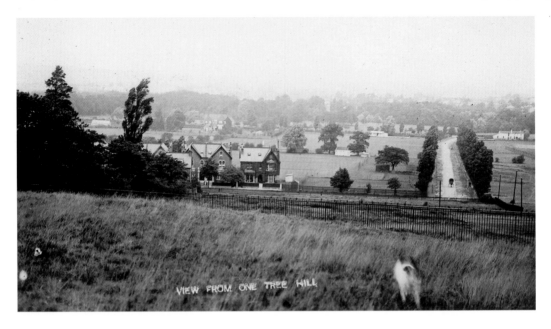

VIEW FROM ONE TREE HILL

One Tree Hill

One Tree Hill saw important environmental protests over a century ago. The campaign to retain the wooded hillside for the enjoyment of the general public lasted from 1896 to 1905. The land was part of the Great North Wood. Until 1896, when it was quietly enclosed by a golf club, the hill had always been a popular open space that people liked to visit. The erection of a six-foot-high fence caused a storm of indignation. The following year, meetings were held on Peckham Rye to protest against the closure. After much campaigning, One Tree Hill was opened in 1905 as a permanent public open space.

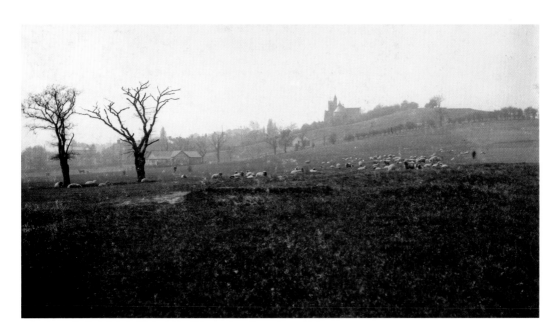

Great North Wood

There is no official boundary for East Dulwich but since 1917 the SE22 postal boundary has been used. One Tree Hill is in SE23 but is included in this book because it is an important part of the London Borough of Southwark and is only a few metres from SE22. One Tree Hill at Honor Oak was the site of an early environmental protest. The campaign to keep the wooded hillside free for the public to enioy lasted from 1896 to 1905. The land was part of the ancient Great North Wood. The photograph above, showing sheep grazing on One Tree Hill, was taken on 4 May 1905.

Waverley School

Waverley School, seen here in 1983, was established in 1978. The upper school used the former Honor Oak School building (opened in 1931) and the lower school was housed in the former Friern Road Schools. Waverley School became the Harris Girls' Academy East Dulwich. A stream runs through the grounds into Peckham Rye Park. It rises between the Honor Oak Reservoir and the school and was a tributary to the River Peck.

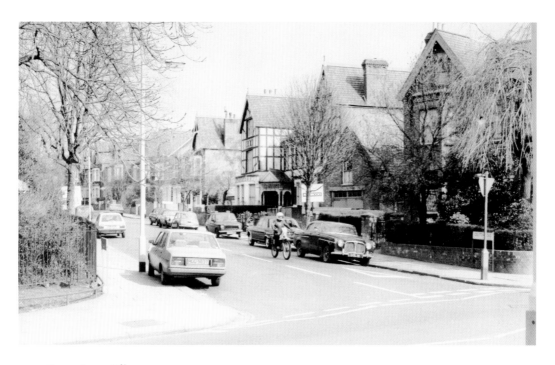

Percy Lane Oliver

The founder of the Blood Donor Service is commemorated with a Greater London Council blue plaque at his former home, 5 Colyton Road. It was unveiled in 1979 and states: 'Percy Lane Oliver 1878-1944 Founder of the First Voluntary Blood Donor Service lived and worked here.' An oil painting of him can be seen in the Haematology Outpatients Department at King's College Hospital.

Piermont Green

The triangular piece of open green space known as Piermont Green is shown on the 1868 Ordnance Survey Map without a name. A path led across it to a large house called Spring Grove. In *The Southwark Plan — the framework for all land use and development in Southwark* (2007) Peckham Rye Park and Common and Piermont Green are included together as Metropolitan Open Land.

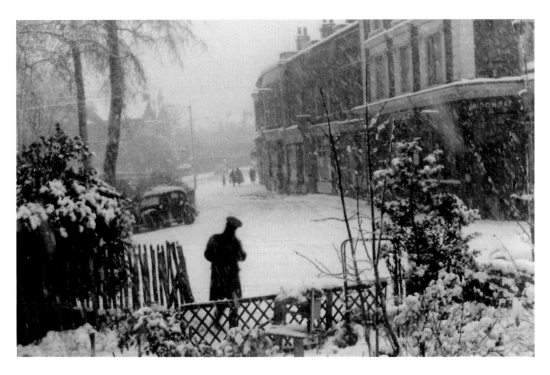

Herne Tavern

Snow in early 1963 covered the road outside The Herne Tavern. Nearby Dunstans Road was the location of an area of land known as Dunstan's Herne, which was purchased by Sir Walter St John for Battersea Grammar School. Dunstans Grove was originally called Herne Grove. The 1868 Ordnance Survey Map names it as 'Dunstan's Hern'.

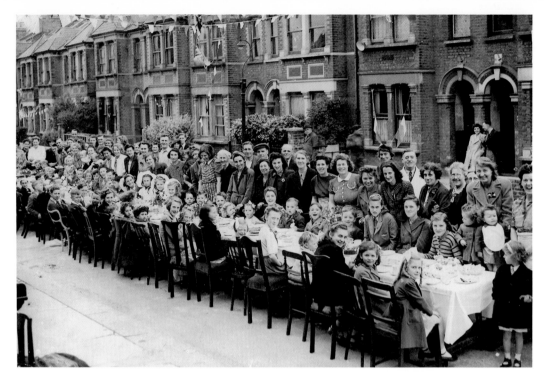

St Aidan's Road

A street party to celebrate the Coronation of Elizabeth II was held in St Aidan's Road in 1953. The road was named in 1884 after the first Bishop of Lindisfarne who died in AD 651. When the road was surveyed in 1899 on behalf of Charles Booth, George Arkell and PC 'Taffy' Jones reported: 'Saw one servant but most of the houses have two families.'

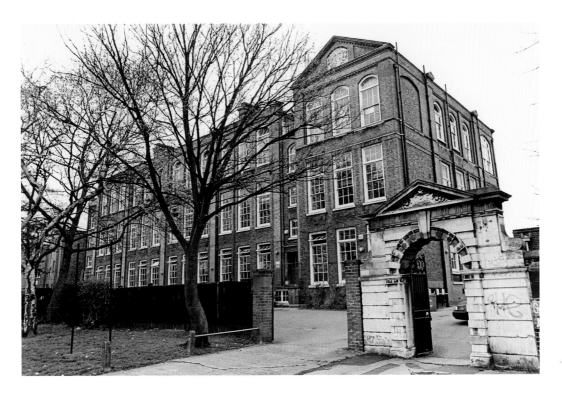

Friern Road Schools

Friern Road Schools opened in 1896 and were later used by Waverley Lower School. There was a 'Special school for Physically Defective Junior Mixed [pupils]' in Friern Road. Despite a vigorous campaign to retain these Victorian buildings and adapt them for future use, they were demolished. A new academy for 950 boys is being built on the site. The only parts of the old school that still exist are lintels with 'boys' and 'girls' on them which have been placed in Peckham Rye Park close to the lake.

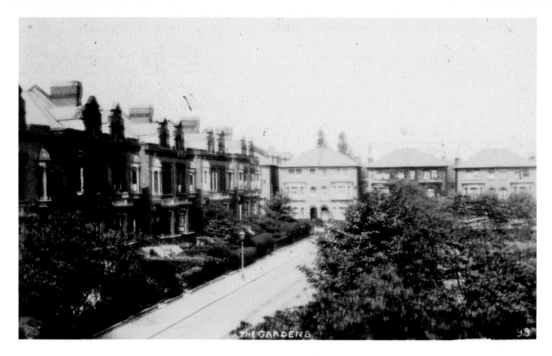

The Gardens

East Dulwich Ward is the only ward in the London Borough of Southwark that does not include public open green space. However, residents who live in The Gardens are able to enjoy a private area of grass and trees. Market gardens occupied the site in the second half of the nineteenth century. In The Gardens is a brick hut in which men slept during the Second World War while they were operating a barrage balloon that was tethered there.

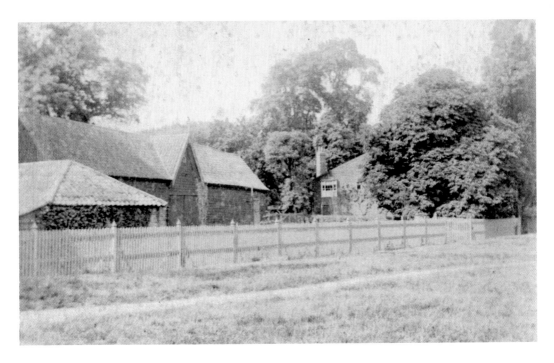

Homestall Farm

Homestall Farm was bought so that Peckham Rye Park could be created. This part of the farm is where the bowling green is today. The photograph below shows the third bowling club pavilion on the site — the previous two were wrecked by arson attacks in 1994 and 2005. The Friends of Peckham Rye Park Newsletter reported in the summer 2008 issue that the park's bowling club was established in 1910 by John Collier, who gave his name to one of the competition shields.

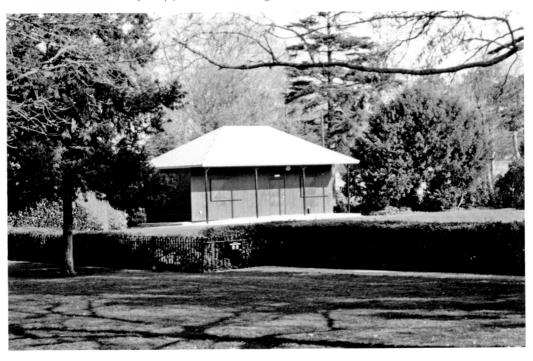

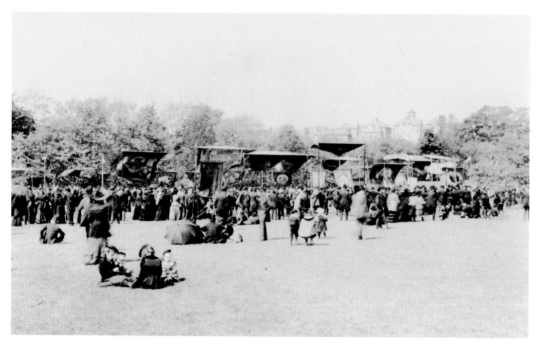

Peckham Rye Park

Peckham Rye Park opened in 1894 on land that had been Homestall Farm. A plaque states that the Peckham Society organised the centenary celebrations on 14 May 1994. Five maple trees were planted a few metres from the plaque. In front of the plaque is a bench which is a memorial to Peter Morris who was a keen member of the Peckham Society committee. He recorded his memories of the neighbourhood in *East Dulwich Remembered.*

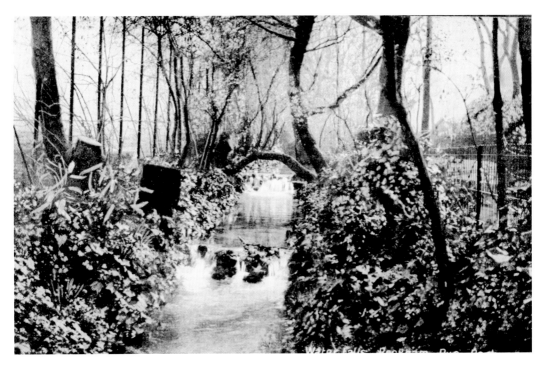

Stream in Park

Peckham Rye Park is in SE22 which is the postal district for East Dulwich; Peckham Rye Common is in SE15. A stream, which was a tributary to the River Peck, rises from a spring between Honor Oak Reservoir and the Harris Girls' Academy East Dulwich.

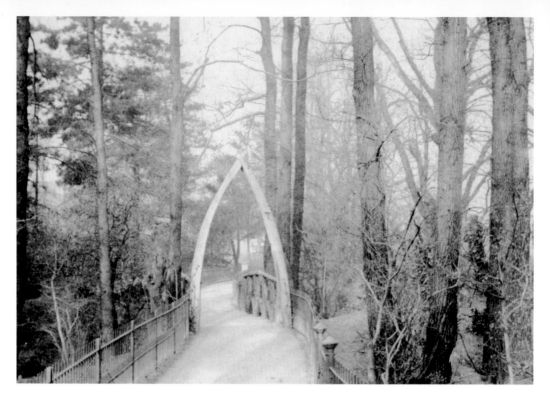

Whalebone Arches

Peckham Rye Park had three whalebone arches. The story of them came to light after the park's centenary was celebrated on 14 May 1994 and was told in *Peckham Rye Park Centenary*. They had been in a person's garden in Homestall Road and were believed to have been provided by a relative who had been employed in the whaling business.

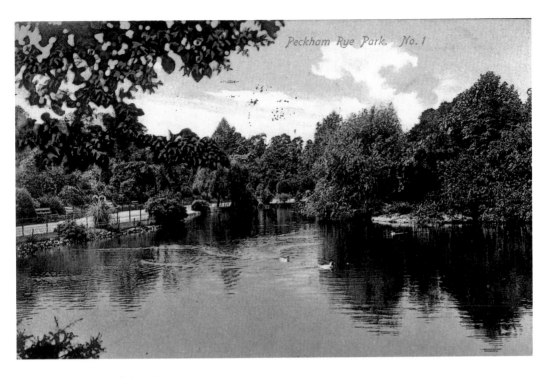

Peckham Rye Park. No. 1

Centenary Celebrations

The lake in Peckham Rye Park was featured on a postcard *c.* 1905. It was also photographed a few weeks after the Centenary Celebrations were held in 1994 and the view appeared on the cover of notelets. Peckham Rye Park is undoubtedly the jewel in the East Dulwich crown.

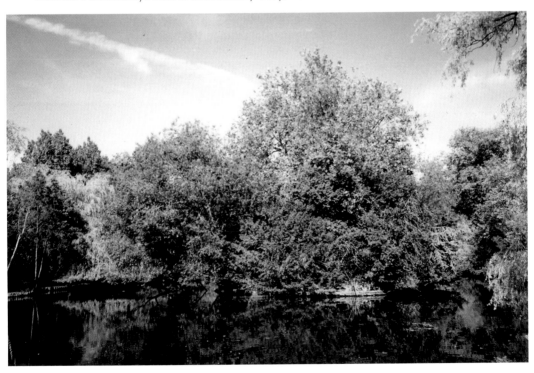

EAST DULWICH
AN ILLUSTRATED ALPHABETICAL GUIDE
JOHN D. BEASLEY

The first book published exclusively on East Dulwich

No longer out of print – second edition published by Chener Books to celebrate the
30th birthday of the only bookshop in East Dulwich

£4.99 (£5.89 with postage)
Chener Books, 14 Lordship Lane, SE22 8HN
Tel: 020 8299 0771